Capital

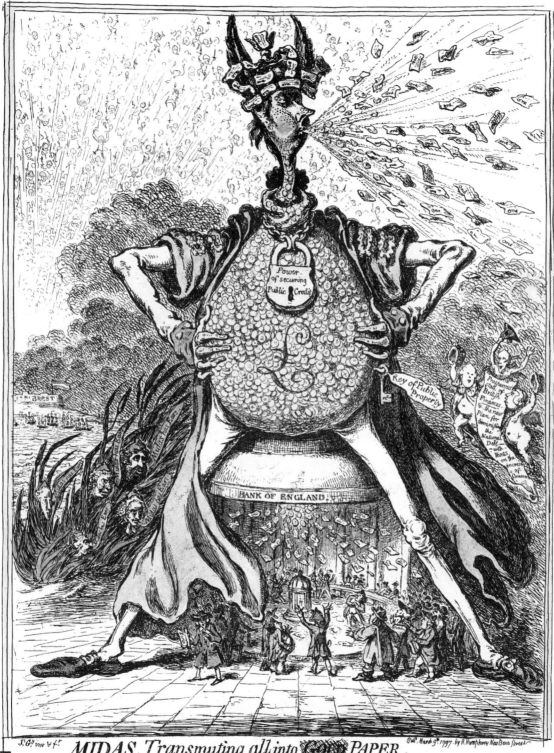

MIDAS, *Transmuting all into* GOLD PAPER.

History of Midas, ___ *The great Midas having dedicated himself to Bacchus, obtained from that Deity, the Power of changing all he Touched*
Apollo fixed Asses Ears upon his head, for his Ignorance ___ *& although he tried to hide his disgrace with a Regal Cap, yet the very Sedges which grew*
from the Mud of the Pactolus, whispered out his Infamy, whenever they were agitated by the Wind from the opposite Shore. ___ *Vide Ovid's Metam:__*

Capital

A project by Neil Cummings and Marysia Lewandowska

for Ana Paula
from Marysia

Dec 2009

Tate Publishing

Published by order of the Tate
Trustees 2001 by Tate Gallery
Publishing Ltd, Millbank,
London SW1P 1LG

ISBN 1 85437 352 8

A catalogue record for this
publication is available from
the British Library

Publication
Design by Stephen Coates
at August, cover by Anne
Odling-Smee at August
Printed in Great Britain
by BAS Printers, Over Wallop,
Hampshire

Limited-edition print
Photograph by Nigel Jackson
Pre-press by Precise, London
Printed in Great Britain by
Balding + Mansell, Norwich

**Seminar Series at Tate
Modern**
Curated with Jeremy Valentine,
and chaired by Paul Hirst
GIFT
Marilyn Strathern and
John Urry
ECONOMY
Jean Joseph Goux and
Scott Wilson
TRUST
Geoff Mulgan and Nigel Thrift

For further information on
projects by Neil Cummings
and Marysia Lewandowska:
www.chanceprojects.com

Artists' acknowledgements
Our special thanks are
extended to the curator
Frances Morris, who
commissioned what has
become *Capital*. The project
has greatly benefitted from her
openness and imagination, as
well as critical input. Sophie
McKinlay's commitment and
meticulous organisation also
helped navigate us through
some difficult terrain.

Our research at the Bank
of England would not have
been possible without the
enthusiasm and guidance
of John Keyworth, whose
assistance and insight has
been greatly appreciated. In
the early stages of the project
we engaged in conversations
with Nigel Thrift and Jeremy
Valentine who helped map
the theoretical ground and
suggested many of the source
readings that form part of this
collection. We are grateful
to them for contributing new
texts, and also to Marilyn
Strathern and John Keyworth
who have kindly allowed us
to include their texts in this
publication. We enjoyed
working with our editor Mary
Richards and would like to
thank her and the whole Tate
Publishing team for supporting
this part of the project. The
seminar series is the result of
an inventive approach by
Andrew Brighton, curator of
Public Programmes at Tate
Modern, and Jeremy Valentine
whose broad knowledge of the
subject helped to choose an
extraordinary range of
speakers. Once again Stephen
Coates has been central to
this collaboration by designing
the book and the limited-
edition print.

Many others at Tate and the
Bank of England have offered
time and expertise over the
last two years. At Tate: John
Bracken, Jane Burton,
Krzysztof Cieszkowski, Meg
Duff, Stephen Dunn, Simon
Faulkner, Adrian Glew, Mark
Heathcote, Caro Howell,
Peter Moon, Lars Nittve, Clair
O'Leary, Derek Pullen, Jane
Ruddell and Piers Townsend.
At the Bank of England: Peter
Rogers and Mervyn King.

Nick Barley and all at
August. As well as: Eileen
Simpson, Teresa Simpson,
Nigel Jackson, Toby Nangle,
Geoffrey Makstutis, Lakshimi
Vishram at the National
Blood Service and Basia LC.

Neil would like to
acknowledge the financial
support of the Research
Committee at Chelsea
College of Art and Design

CONTENTS

FOREWORD
6

GIFT, ECONOMY, TRUST Frances Morris
8

FROM A NATIONAL TO A CENTRAL BANK John Keyworth
16

IT'S THE THOUGHT THAT COUNTS Neil Cummings and Marysia Lewandowska
30

I.O.U. NOTHING Jeremy Valentine
36

THE AESTHETICS OF SUBSTANCE Marilyn Strathern
56

ELSEWHERE Nigel Thrift
82

A SHORT HISTORY OF THE TATE GALLERY Frances Spalding
106

BIBLIOGRAPHY
111

FURTHER READING
112

On the eve of Tate Modern's first anniversary it is, more than ever before, important to remember that the building by no means equals the museum. Whilst we build galleries for modern and contemporary art because the majority of work is (or has been) made with the gallery space, or 'white cube', as the work's ideal viewing place, at the same time artistic practice of the last forty years has in many ways undermined the hegemony of the gallery building.

During the recent past many artists have moved from the production of objects and images to exploring what perhaps can be called a zone or a field, within which a variety of activities (including drawing, painting and sculpture) produce and reveal meanings, power systems and values. This process does not mean that the museum now has a less important role, only that its role has shifted and expanded into that of being a central operator or, perhaps, hub in a complex cultural field.

I can think of no artists that have ventured into investigating the nature and role of the museum and the category of activities in society we call art with such mix of curiosity, clarity and radicality as Neil Cummings and Marysia Lewandowska. I am therefore delighted that they agreed to inaugurate the *Contemporary Interventions* programme at Tate Modern – a programme of annual commissions through which we enable artists and others to investigate and comment on the core practice of the museum. With their project *Capital*, the artists have cut through and laid bare layer upon layer of micro- and macro-systems of structure, meaning and value in the museum, and the broader context in which it operates; from its secret and private spaces, via its location on Bankside, to its place in society's systems of value, production and exchange.

Capital, as an artwork, is triggered by an act of giving, this book and by a series of discussions curated by the artists. It has been in planning for several years and has been an intensely collaborative project. I would like to thank Neil and Marysia for their tenacious ambition, inspired thinking and meticulous attention to detail in realising such a complex venture. I would also like to add my personal thanks to the many individuals, listed in Neil and Marysia's own acknowledgements, at Tate Modern and the Bank of England who have supported the genesis and realisation of *Capital*, to the distinguished writers who have contributed to the book, the speakers participating in the seminar series, and to the design team at August. *Capital* is a key part of *Tate Modern: Collection 2001*, which is generously supported by BT.

Lars Nittve, *Director, Tate Modern*

FOREWORD

Going to the Tate Modern?

Do not exit here

The nearest station is Southwark on the Jubilee line. Take the Victoria line to Green Park and change there.

Pimlico is the station for the original Tate Gallery, now known as the Tate Britain.

Esca
Updat

A number of escal
following tempora

These escalators a
have to take them
driveshafts and ma
work starts in the

We are already fittin
other escalators as

The following list c
are long term escal
you may have to w
platforms so please

Baker Street
Bethnal Green
Bond Street
Brixton
Charing Cross
Clapham South
Euston
Holborn
Hyde Park Corner

Miscellaneous ephemera – assorted plastic bottles, second-hand furniture, boxes of leaflets and collections of magazines, children's toys, old kitchen utensils. Some items are shelved according to a discernible method of classification – plastic bottles by colour for example, or chairs arranged according to function around a coffee table. Others are gathering dust in random assortments, thrown into conversation with each other, mimicking in microcosm the ways in which our lives are entangled with the myriad things we encounter – how we use, value and distribute objects, and how their use and value changes according to context and through time.

This is not a description of some rarely visited junk shop but of Marysia Lewandowska and Neil Cummings's London studio: a space set aside not for the making of objects but for their study and speculation. Marysia and Neil are not only interested in the methods of classification that are ordinarily ascribed to 'things', but also in the connections and meanings vested in objects through their associations and relationships. The objects in Marysia and Neil's studio are not in fact random, but have been collected and placed by them, removed from the context of their acquisition, and become part of the artists' own material and intellectual world. A cylindrical aluminium steamer (the kind used for baking sponge puddings) rests on the shelf. Manufactured and sold to fulfil a particular function, it has participated in a generation of school dinners, performed as a commodity within the second-hand market, been transformed into a novelty handbag through the addition of a simple drawer-handle, and, finally, been returned to the shelf alongside a profusion of other things.

Like everything that is made, the steamer has not only a generic use but also a personal history that goes beyond function and is accrued over time. Marysia and Neil are interested not just in those generic meanings but in the ways in which the individuals and the institutions that produce, disseminate, collect and discard things themselves collide with the object in generating new relationships, meanings and value. In his introduction to *Reading Things* (1993) Cummings asserted: 'Most of our material world, like the iceberg, lies beneath the threshold of our comprehension.' Marysia and Neil's collaborative practice over the last few years has explored this threshold as both a physical and discursive space. It is a physical space because objects have a material presence and occupy space and time bound by other materials: they are embedded. The discursive space is mapped out by the way in which a thing is understood, the way it is described, categorised, compared or exhibited. The amazing variety of words we employ to denote particular types of objects (product, art object, commodity, relic, property, item, thing, fetish, memento) suggests the richly evocative,

multifaceted profiles of 'things' within our material culture.

In several projects Marysia and Neil have drawn our attention to some of the ordering devices that bring things into association. *Lost Property* (1996) is a book documenting a selection of the items recovered by the London Transport Lost Property Office in a single day. Utterly disparate, the objects are united by their shared experience. Cut adrift from their owners and the intimate, personal stories attached to 'possession', they evoke the emotional investment that we make in the objects we acquire, and the experience of loss that comes with their unexpected absence.

Not Hansard: the common wealth, at the John Hansard Gallery in May 2000, took as its starting point the founding of the Gallery in 1979, with an endowment from the Hansard family, publishers of the daily Parliamentary journal. *Hansard* records everything spoken in parliamentary debates.

Over a period of many months, Marysia and Neil collected hundreds of magazines, journals and newsletters – not commercially available – produced by clubs, societies, hobbyists, collectors, enthusiasts and associations. By requesting the first issue of the new millennium, the collection represents the interests, hopes and aspirations of a vast and varied society; those generally invisible amongst the relentless flow of the professionally mediated. Presented in the gallery as a Reading Room for visitors, the astonishing variety of social life finds a printed form, before its inevitable replacement by digital means of distribution, via on-line news groups and networked noticeboards.

An existing archive, that of the Design Council, was the location of a year-long residency with the Council's Archive in collaboration with the University of Brighton in 1999–2000. The 1951 'Stock List' drawn by the Design Council, represented by the artists in *Documents* (2000), was an inventory of products and machinery produced to document and promote officially endorsed British design. Described by Marysia and Neil as 'an extraordinary poem to materiality composed by Britain's post-war ruling classes' in which 'an uncanny portrait emerges of the people and forces that shaped it, full – as it is – of their obsessions and anxieties of finding order or value among things'. An echo of this portrait runs through the *Documents* website (www.documents.org.uk) via which the *Stock List Browser* activates a search of the web, overlaying one inventory with another.

In such projects Marysia and Neil prompt an enquiry into the relationship between things, value and context, by deliberately juxtaposing or colliding separate systems of classification. Commercial and museological methods of presentation and evaluation were the subject of the in-store leaflet *Browse*, part of a wider project entitled *Collected* (1997), in which a series of objects

selected from the British Museum and Selfridges Department store were presented together in order not only to compare notions of value but also the ways in which each institution communicates those notions to its visitors, via systems of display and interpretation. Continuing and developing this further is their book *The Value of Things* (2000), which its publishers Nick Barley and Stephen Coates rightly argue acts as a 'manifesto for a form of artistic practice which can take place successfully outside the realm of the gallery'.

Capital has evolved over a number of years. Initially invited to propose a project as part of Tate Modern's pre-opening programme, Marysia and Neil spent some time considering Bankside's location within Southwark, a borough which borders the River Thames, opposite the City of London and is bound historically through complex cultural and economic links to the history of Britain's financial heartland. Out of this research has come another rich and provocative juxtaposition, between the Bank of England and Tate. Each institution sits astride a vastly complex local, national and international network of dependencies. Since its inception in the late seventeenth century the Bank of England has served the needs of the state as well as the needs of private financial organisations. It regulates our domestic economy by managing the issue and price of debt and as

Though the Earth, and all inferior Creatures be common to all Men, yet every Man has a *Property* in his own *Person*. This no Body has any Right to but himself. The *Labour* of his Body, and the *Work* of his Hands, we may say, are properly his. Whatsoever then he removes out of the State that Nature hath provided, and left it in, he hath mixed his *Labour* with, and joyned to it something that is his own, and thereby makes it his *Property*. It being by him removed from the common state Nature placed it in, it hath by this *Labour* something annexed to it, that excludes the common right of other Men. For this *Labour* being the unquestionable Property of the Labourer, no Man but he can have a right to what that is once joyned to, at least where there is enough, and as good left in common for others.

[...] This is certain, that in the beginning, before the desire of having more than Men needed, had altered the intrinsick value of things, which depends only on their usefulness to the Life of Man; or [Men] had *agreed, that a little piece of yellow Metal*, which would keep without wasting or decay, should be worth a great piece of Flesh, or a whole heap of Corn; though Men had a Right to appropriate, by their Labour, each one to himself, as much as the things of Nature, as he could use: Yet this could not be much, nor to the Prejudice of others, where the same plenty was still left, to those who would use the same Industry. To which let me add, that he who appropriates land to himself by his labour, does not lessen but increase the common stock of mankind.
John Locke, *Two Treatises of Government*, 1679

'lender of last resort' it underwrites the
functioning of immensely complex commodity
and money markets, both at home and abroad.
Tate, Marysia and Neil propose, can be seen
as the principal agent in a parallel 'symbolic
economy', underwriting the integrity and value
of the artworks in which it deals and thus
ensuring the stability and health of a network
of interconnected relationships which constitute
the art world.

The exchange created when two disparate
objects, images or materials are brought together
can be of many kinds including physical, poetic,
psychological and intellectual. The desire to
generate and heighten the charge of such
encounters has driven many of the paradigm
shifts within modern art from Surrealism to
Arte Povera. Marysia and Neil have extended this
kind of attention from objects themselves to the
institutional structures that lend them meaning.
Money leads us to the banking world, art to the
world of galleries and museums.

Giving is always part of a system of exchange related,

The artists have worked, not towards the production of a final art-object, but
through the gathering of information, through conversations, accumulating
images and their organisation and analysis, upon a kind of research project.
They are interested in an interdisciplinary approach to new territory.
Institutions like Tate and the Bank of England may seem familiar to the
people who move within their orbit, but made adjacent through layering
they become strange new topographies. For *Capital* the artists have
assembled photographs of both institutions, their public spaces and
private zones, in an attempt to make visible their operations, systems and
secrets. For those of us comfortable in one or other of these realms there
is a continuous interchange between the familiar and the unfamiliar. This
book consists of a collection of images taken by the artists, archival material
from both institutions and a series of texts, some commissioned, others
selected from both the academic and more popular fields, which create
dialogues of exchange between voices that might never otherwise – like
the objects in the studio – have met in discussion.

For visitors to Tate Modern this exchange is dramatically realised in an

act of giving. At selected times arbitrarily chosen visitors will be given
a limited-edition print, issued by the artists, through a gallery official. This
unexpected gesture acts like a detonator, throwing up many questions. What
does it mean to give and receive in these circumstances? What is asked for
in return? What value can be given to the work of art and what values or
meanings will it gather or discard, as it moves from the gallery and into the
wider world of its new owner? *Capital*, the gift, is thus a gesture as much as a thing.
To the artists this publication and the series of seminars that they have
curated – with Jeremy Valentine – on the themes of gift, economy and trust
provide the aesthetic and discursive terrain for the gift's reception.

Both Tate and the Bank of England were established by the act of giving. In 1694 the Bank
was initiated by a loan to the government raised by public subscription.

The Bank's founding charter states that its role is 'to promote the public
Good and Benefit of our people'. Tate was founded by a gift from the
sugar magnate Sir Henry Tate in 1897. In 'I.O.U. Nothing' the cultural
theorist Jeremy Valentine disentangles the web of meanings caught up in
the notion of giving. Semantically linked to debt through its Greek roots,
giving has been the subject of a vast body of research in the fields of
anthropology, philosophy and other disciplines within the social sciences
and humanities since the early twentieth century. It has more recently
developed well beyond economic reflection to become a theme within
cultural theory and art.

but distinct from commodity exchange, and incurs both rights and obligations. While money markets
are regulated through strict financial mechanisms operating the control
of debt, interest and credit, other ways of exchange exist beyond, and
historically predate, financial systems. At various times and in different
places exchange networks have been governed by alternative cultural
regimes. In 'The Aesthetics of Substance', an extraordinary investigation
of two separate communities in the highlands of Papua New Guinea,
the anthropologist Marilyn Strathern unfolds contrasting practices of
exchange which, she demonstrates, are reflected in the two communities'
fundamentally different attitudes to the physical body, and by implication
their relationships to power.

Within discourses around systems of exchange the notion of philanthropy
or doing good is particularly problematic. Tate's history is strongly inflected
by the different expectations and obligations incurred through the various
acts of benefaction that have enabled its development. Tate's charitable
status, which defines it as existing for the altruistic benefit of others, means
that it cannot engage in any kind of commercial activity. For some the
return on giving may be a warm glow of self-righteousness; for others it

might be respect, power or status. In recent years systems of giving to public institutions like Tate have become more sophisticated and subject to regulation. Organisations of friends, members, patrons or partners exist to encourage giving and to quantify the return. The 'naming' of spaces, public acknowledgement of gifts, or annual dinners are, for example, some of the ways in which acts of individual and corporate giving are made known and returned. As a public institution entrusted to care for the nation's collection Tate returns benefits to the taxpayer. It does so by making the collection publicly available – hence its commitment to free entrance; it cares for the collection, storing it adequately when not on display, conserving it from the ravages of time, making it available as loans to institutions and communities far away from its metropolitan base. These are tangible benefits, quantifiable in statistics (numbers of loans, numbers of visitors) but there are also invisible benefits: our culture values aesthetic experiences; we deem them of moral and intellectual worth. Tate's educational programmes encourage access and facilitate interpretation with the aim of enabling ever more people to enjoy and understand the objects in its trust. *Capital* as a project is itself part of this system of interpretation. It inaugurates *Contemporary Interventions*, a programme of annual commissions through which Tate Modern enables other voices to comment on, and engage with, aspects of its core practice.

When Henry Tate made his foundation gift, the donation was not just of money but of paintings and sculpture; objects requiring a building within which to display their material and aesthetic presence. Today the Gallery operates within a cultural field in which the 'making' of art is no longer always associated with the making of tangible products. The historical process of de-materialised practices endorses walking, writing, performing and thinking as valid 'aesthetic' gestures. Technologies such as film, video and digital media allow artists to participate in a broader experience of the world. Some artists have become commentators, activists, analysts, curators, and their commitment has shifted from purely art-conscious to a more socially conscious practice. Artists make work in ways that question the centrality of still popularly celebrated concepts of craft, skill, truth, uniqueness, aura and so on. In a parallel trajectory the physical banknotes and coins we carry in our pockets seem to have less and less connection with the software that allows us to make our domestic monetary transactions on screens, or enables financial institutions to move vast quantities of capital around the world at the touch of a button. The move towards the intangible has not happened without resistance in either sphere. The introduction of paper money in the 1720s was widely

At the heart of their project

distrusted, as was the Bank's departure from the gold standard in 1931. In the world of art there has been an equivalent professional and public resistance to conceptual and new media art practices. However, in both cases the move towards what the geographer Nigel Thrift calls the 'realm of the insubstantial' has been inexorable. It has happened because our ultimate trust in these economies, either financial or symbolic, has never really been shaken. According to Thrift both rely on formidable 'value' systems which underwrite our trust in things that are 'barely representable'. Both developments have taken place in a world where many of our daily experiences are increasingly less substantial: with television, cinema and the Internet effecting a fundamental change in the way we perceive our world and ourselves. The economy is now so complex that few can begin to understand the abstract systems on which it relies. A vast media produces an extensive daily commentary as experts advise us on both the global perspective and our own financial needs. Among the structures that underpin the value of dematerialised practices in art, Thrift cites a commercial market which has found ways of selling the insubstantial; collectors who are willing to buy the intangible; a supporting cast of critics and art historians who substantiate its aesthetic claims; and museums and galleries' curators who define the practices they support as art.

 Marysia and Neil's conceptually-based practice, and this project in particular, is symptomatic of this landscape of the insubstantial. the giving of the gift unsettles, disturbs and challenges our customary expectations of art. Around this

explosive gesture, the *Capital* seminars and book bring together a range of voices from a number of fields. They are willing to engage in an interdisciplinary debate, operating through a different kind of exchange mechanism – that of ideas. The ideas these exchanges result in may not be as comfortable as the cosy seminar format in which they take place. Marysia and Neil's practice brings us into new and possibly unfamiliar territory in which the structures and institutions we may have taken for granted are vividly rediscovered.

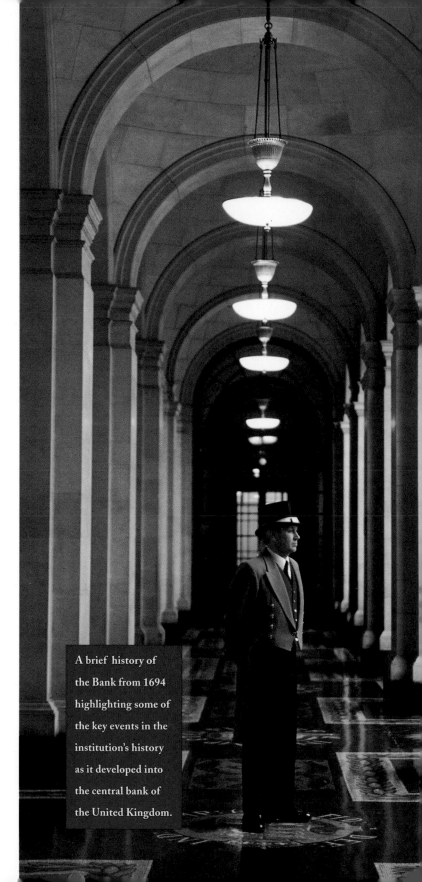

A brief history of
the Bank from 1694
highlighting some of
the key events in the
institution's history
as it developed into
the central bank of
the United Kingdom.

from a
NATIONAL
to a
CENTRAL
Bank

Capital ?

From the middle of the 17th century, England and London in particular, buzzed with ideas - indeed the era has been dubbed 'the age of projects' - but one which kept coming to the fore was the notion of a national bank. People sensed that the country was on the brink of a tremendous expansion of trade, but one vital element was lacking: what was needed was a bank or *"fund of money"* - more liquidity, in modern parlance - to drive the trade of the country. They looked with some envy across to the continent at the example of the Dutch who were then pre-eminent in Europe.

Central to the success of the Dutch was the Amsterdam Wisselbank, which had been founded in 1609. It provided the motive power for the Dutch economy by lending to the City of Amsterdam, the State in the form of the Province of Holland and trade in the shape of the Dutch East India Company as well as being responsible for coinage and, of course, exchange. Much later, in 1683, it was empowered to lend to private customers. Payments over a certain amount had to pass through it and it therefore was convenient for the important finance houses to hold accounts with it. Thus not only was it in a position to oversee the Dutch financial scene, it was also able to act as a stabilising influence on it.

In England the argument for some kind of bank began to gather momentum after the Glorious Revolution of 1688 when William of Orange and Queen Mary jointly ascended the throne of England. The political economist Sir William Petty had recognised from the example of the Dutch that successful credit-based trading could benefit a nation in many ways and help to enlarge its sphere of influence: he wrote in 1682 *"What remedy is there if we have too little Money? We must erect a Bank, which well computed doth almost double the Effect of our coined Money; and we have in England Materials for a Bank which shall furnish Stock enough to drive the Trade of the whole Commercial World".*

Above: Mercers' Chapel Cheapside c.1700 where the Bank carried on its business until December 1694.

Roman pavement found on the Threadneedle Street site of the Bank in 1805. The origins of London as a trading centre date from Roman times.

1

*D*utch William had brought to his adopted country an understandable desire to help his native country in its war against the French and this proved to be the catalyst necessary for the idea of a national bank to be accepted, albeit grudgingly by some.

But it took a London-based Scots entrepreneur, William Paterson, to propose the scheme that eventually found favour: his first, proposed in 1691, had been rejected for several reasons. This was partly because, as he wrote in 1695, *"Others said this project came from Holland and therefore would not hear of it, since we had too many Dutch things already"*. Under his scheme, in return for a loan of £1 million, the bills issued by his company should be made legal tender. This idea proved to be more than a century ahead of its time, and consequently unacceptable to the Parliamentary Committee.

After several more rejections Paterson put forward a plan for a 'Bank of England' and a 'Fund for Perpetual Interest' although this time bills were not mentioned. Supported by two powerful personalities - Charles Montagu, Chancellor of the Exchequer, who looked after the Parliamentary lobbying, and Michael Godfrey a leading merchant who ensured the idea's acceptance in the City - it was all but inevitable, given the Government's pressing need for funds, that the scheme should be approved by Parliament. So Paterson's plan was accepted and the necessary Act passed. The public were invited to invest in the new project and it was these subscriptions totalling £1.2 million that were to form the initial capital stock of the Bank of England and were to be on-lent to Government in return for a Royal Charter.

The Government's immediate motive for creating the Bank was its pressing need for money - Paterson himself said that the Government accepted his proposal only as *"a lame expedient for £1,200,000"*. And for some time afterwards the Government saw the Bank in that light - renewals of its Charter had to be paid for with loans, often painfully negotiated, from the Bank to the Exchequer. There was little in the Act creating the Bank to hint at what it would become - certainly no suggestion of a central bank, scarcely a hint of banking at all. But the Charter was enough. The Bank was big, it was incorporated with limited liability (extremely rare then) and it set out to take full advantage of this position.

William Paterson (1658-1710) the Scots entrepreneur who proposed the successful scheme by which the Bank of England was founded. He served as a Director from July 1694 and retired in early 1695.

Opposite: The Bank's 1694 Charter set out how the new corporation was to be run in order 'to promote', as the document itself states, 'the publick Good and Benefit of our people'.

Subscriptions to Bank of England Stock – the capital stock of the institution and the start of the Funded National Debt – were taken in between 21st June and 2nd July 1694. Amounts subscribed varied between £25 and £10,000.

[Handwritten marginalia:] loan: a gift where the return is contractually agreed.

[Handwritten marginalia:] a loan in exchange for a Royal Charter + interest?

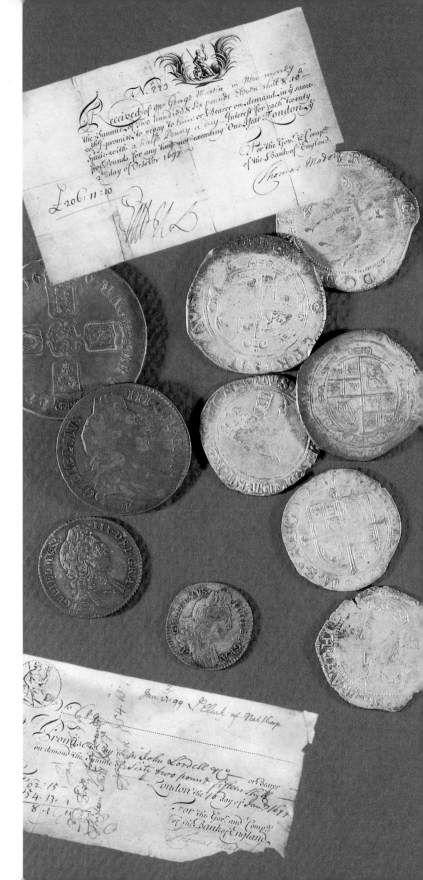

To start with, the Bank was the Government's banker: managing the Government's accounts; managing (at some expense to itself) the recoinage of 1696; providing and arranging loans to the Government. It was also a commercial bank, dealing in bills - the then equivalent of overdraft finance, furnishing finance for trade. It took deposits and issued notes, and with the development of the issue function it began to realise the dreams of some of the original projectors, of a Bank that would *"double the Effect of our coined Money"*.

One particularly significant development around this time lay in the perception of credit or 'imaginary money' as it was then called. It represented a fundamental and distinctive principle in the new thinking that was so prevalent during this age of ideas and experiments. Projectors had begun to recognise the existence of an untapped source of assets, albeit non-metallic, such as stocks of merchandise, tax receipts, revenues on land and commercial obligations, against which 'credit' or 'imaginary money' could be raised. Credit could be, they argued, the seed corn of wealth. But what was money? To the man in the street, money simply meant coins, but the new thinking was overturning that shibboleth: it was suggesting that money could take other forms which would have no intrinsic value and yet still possess qualities to enable it to be used to make payments thereby fuelling and lubricating the economy. It was inevitable, therefore, that when theory became practice and the funded National Debt was born that crucial element, paper money, almost simultaneously completed the equation.

Opposite: Examples of some of the coins circulating until 1697. Many were in a poor condition having been clipped or filed or otherwise diminished in weight.

Specie note for £206-11s-10d issued on 2nd October 1697. It promised to pay the depositor 'Mr George Martin' in 'new money', that is to say in the full weight coinage issued since the Great Recoinage of 1696.

Running cash note – the forerunner of today's bank notes – issued to John Lordell in January 1699. Originally for £62-15s – it was partially encashed leaving a balance of £8-1s-11d.

See Nigel Thrift Elsewhere – writing on the insubstantial. P. 85

The 18th century was a period dominated by governmental demands on the Bank for finance: the National Debt grew from £12 million in 1700 to £850 million by 1815, the year of Napoleon's defeat at Waterloo. Reliance by government on the Bank had developed to such an extent that at the renewal of the Charter in 1781 the Prime Minister, Lord North, described the Bank as *"from long habit and usage of many years a part of the constitution"*, and that it was *"......... to all important purposes the public exchequer"*. North went on to explain that *"......... all the money business of the Exchequer"* was *"done at the Bank, and as experience had proved, with much greater advantage to the public, than when it had formerly been done at the Exchequer."*

Above: The Tally stick, a medieval method of accounting, was employed by the Exchequer until the beginning of the 19th century. Tally sticks were given to the Bank as receipts for part of the £1.2 million invested by the public and loaned to the Exchequer.

Yet the Bank, as its Directors were well aware, was taking a risk. In creating credit - issuing notes that were not fully backed by cash (gold) in hand, but were partly supported by credit given to the Government or to commerce - it rendered itself liable to a run. As with any modern bank, if all its depositors wanted all their money back at once, the Bank would fail. There were some close shaves. During the 1745 rebellion, the Bank was paying out in sixpences as news of the Jacobite advance came through. The reserve proved enough - but only just. The constraint on the capacity of the Bank to create credit - which would now take the form of some kind of monetary target - was then, quite simply, the need to maintain a prudent reserve of gold, so that liabilities could be met on demand. This natural banking prudence was the first manifestation of the Bank's long pursuit of the central banker's goal, monetary stability.

Eventually, though, prudence and discretion proved insufficient. The Bank was the nation's bank, and at times of natural crisis its gold reserve was needed for national purposes.

The wars with France which began in 1793 and lasted some 22 years put an enormous strain on the nation's finances. In 1797 the Government was obliged to protect the gold reserves for the war effort by declaring the Bank's

an economy where all the forces balance out: ~~just~~ ?

Above: Gold bars in the Bank's vaults. The Bank has traded in bullion from its very beginning and from the middle of the 18th century was regarded as the 'repository of the nation's wealth.'

tate ?

notes inconvertible. This 'Restriction Period', as it was known, continued for six years after the end of the war, until 1821. Because of the consequent shortage of coin the Bank issued £1 and £2 notes to keep the wheels of trade turning; but, inevitably, prices rose generally and this provoked a fierce debate and the setting up of a Parliamentary Select Committee which attributed the country's difficulties mainly to the Bank's over-issue of paper. The Committee argued that a paper currency which had ceased to be convertible into gold or silver coin could only be kept up to its proper value by limiting its quantity, in that way it would become again a sound currency. Monetarism was born.

linking / not linking paper to gold. Thrift p. 93

There were many small banks issuing notes at this time and by no means were all of them sound. The hard time road to monetary discipline, which followed the return to convertibility, inevitably led to the failure of many of these partnerships which had irresponsibly expanded their note issues. The Bank of England's difficulties were neatly summarised in 1830 by William Cobbett, who could never be described as a friend of the Bank: he wrote *"The Bank is blamed for putting out paper and causing high prices; and blamed at the same time for not putting out paper to accommodate merchants and keep them from breaking. It cannot be to blame for both and indeed is blamable for neither. It is the fellows that put out the paper and then break that do the mischief"*.

Left: The Threadneedle Street frontage in 1828 – the year in which the architect John Soane completed the encirclement of the Bank with a windowless wall. From the painting by J. Arnout.

The Country Bankers Act, a milestone in the development of banking in England, was passed by Parliament in 1826. It breached some of the Bank's former privilege by permitting the establishment of joint-stock banks with more than six partners but not within 65 miles of London. The Act allowed the Bank to establish branches in the major provincial cities from which it was able to increase its sphere of influence by sound note issue. In 1833, the Bank's notes were made legal tender for all amounts above £5, ensuring that in the event of a crisis, as long as the credit of the Bank remained good, the public would be satisfied with its notes and its reserves would consequently be safeguarded.

Regarded by some as the first move towards nationalisation, the 1844 Bank Charter Act was also the key step towards the Bank achieving the monopoly of the note issue. There were to be no new issuers of notes and those whose issues lapsed, or who were taken over, forfeited their right to issue. But the crucial clause of the Act was a monetary one: it provided that beyond the Bank's capital of £14 million, its notes were to be backed by gold coin or bullion. This, together with a fixed price for standard gold, laid the foundation for the gold standard which, during the nineteenth century, spread worldwide and created a long period of price stability with monetary policy, in effect, on auto-pilot.

Monetary stability alone, however was not enough. There were, of course, crises and in order to prevent systemic collapses the 1844 Act had to be suspended: this occurred in 1847, 1857 and in 1866 when Overend Gurney, one of the most prestigious City houses failed. Walter Bagehot, the celebrated editor of the Economist wrote in 1866 about the Bank's part in the crisis of that year that the Bank held, should hold and should be responsible for holding *"the sole banking reserve of the country"*. If the Bank had been slow to recognise its responsibility for financial stability in earlier cases, its reaction in 1890, when Baring Brothers were threatened, heralded a new era in the Bank's stewardship of the Square Mile. A rescue operation in the form of a guarantee fund was orchestrated by the Governor of the Bank and more than £17 million was promised, much of it from the by now powerful joint-stock banks. The crisis was averted but the leading role played by the Bank demonstrated the responsibility it had come to feel for the stability of the banking system as a whole.

Below: 'Same Old Game': cartoon by Sir John Tenniel published in November 1890 in Punch and referring to the Baring crisis. The Old Lady is shown dipping into her reserves to rescue the merchant bank from the results of its speculation.

"SAME OLD GAME!"

Opposite: The United Kingdom goes off the Gold Standard, 21st September 1931.

Handwritten annotations: Trust ? — the 'lender' of last resort' — see Thrift an the gold standard p. 93 — stabilty ?

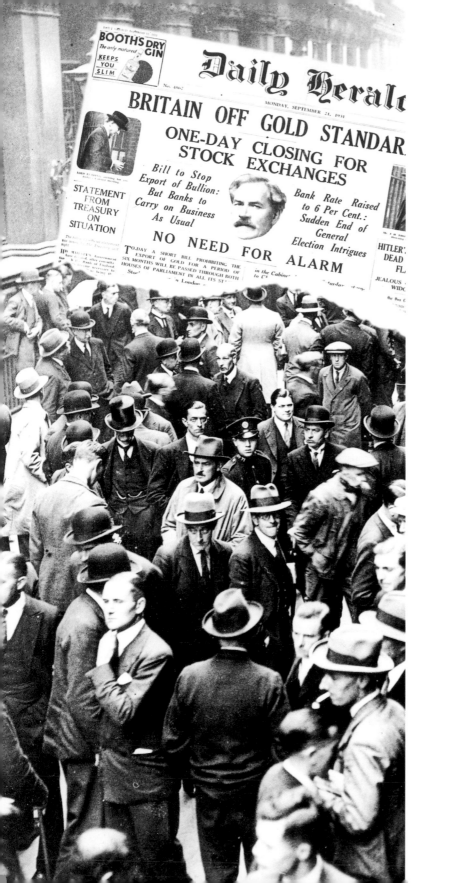

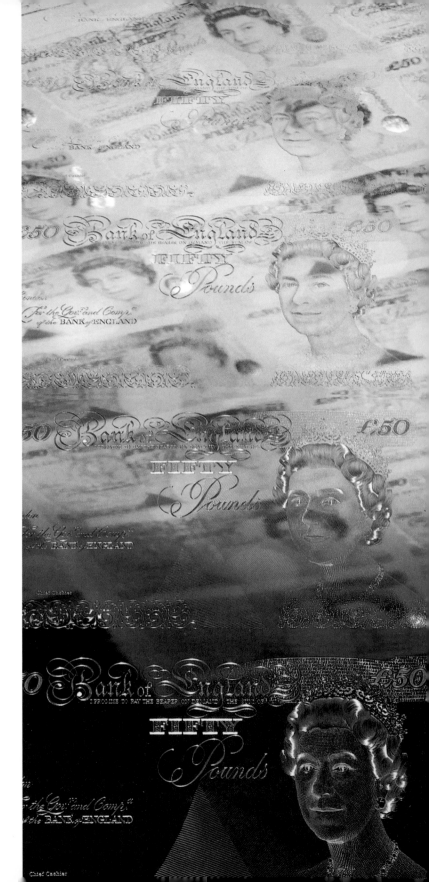

The Bank's second century had thus seen the two key elements of central banking emerge - the concern for monetary stability, born during the inflationary excesses of the Napoleonic wars; and the responsibility for financial stability, developed in the banking crises of the mid-19th century.

As with the French wars a century before, the First World War saw the link with gold broken and the issue of low denomination notes once more. A vain attempt was made in 1925 to return to the discipline of the gold standard but it failed and in 1931 the United Kingdom left the standard for good. The country's gold and foreign exchange reserves were transferred to the Treasury although their day-to-day management was and is still handled by the Bank. The note issue became entirely fiduciary, that is to say not backed by gold.

During and after the war internal changes began to take place at the Bank, presaging the modern Bank. The Governorship, which had until then generally been held for two years only, and then sometimes on a part-time basis, became a full-time professional post. Lord Cunliffe served for five years; Montagu Norman for twenty-four. Specialists were recruited to the staff. Relations with overseas central banks were built up. During Montagu Norman's governorship (1920 - 44) the Bank deliberately moved away from commercial business and increasingly assumed the role of a central bank. Assistance was given in the rationalisation and redeployment of a war-based economy to one which might help to rebuild war-ravaged Europe, and Norman was one of the leading players in the establishment in 1931 of the Bank for International Settlements - a forum for central bankers - in Switzerland.

And the relationship with the Treasury changed. The funds which the Bank was deploying in its operations in the market were increasingly public funds. As noted earlier, the gold and foreign exchange reserves passed to the Treasury in 1931. Norman once famously remarked that he was *"the instrument of the Treasury"*.

Nationalisation, after the Second World War, therefore made little immediate practical difference to the Bank. It shifted final authority over monetary policy to *"the other end of town"*, but that tendency had been established years earlier. The Bank remained the Treasury's adviser, agent and debt manager. During and for years after the war it administered exchange control and various borrowing restrictions on the Treasury's behalf.

Opposite: Sheet of £50 Series E bank notes mirrored by an intaglio printing plate.

bank-notes became 'pure' signs, backed by other paper promises.

Montagu Norman, Governor 1920-44, from a painting by A K Lawrence.

1950's still managing the price of debt

*T*he cheap money policies in the 1930s persisted for some years after the war, but during the 1950s and 1960s (partly under the influence of the Radcliffe Report, but more importantly as a result of US academic work) there was a revival of interest in monetary policy. As the apparatus of post-war controls was gradually lifted, the need for an active monetary policy became more evident, and the serious inflation of the 1970s and early 1980s proved the catalyst for change. Monetary targets were introduced in 1976, and reinforced in the early 1980s. These proved unreliable as a sole guide to policy, but the consensus was clearly established: price stability is desirable in its own right and a necessary condition of sustainable growth; inflation **reduces** growth and has other social costs; inflation is a monetary phenomenon; and without appropriate monetary measures inflation cannot be properly brought under control.

In 1997 the Government announced its intention to transfer full operational responsibility for monetary policy to the Bank of England. The Bank thus rejoined the ranks of the world's "independent" central banks. However, debt management on behalf of the Government was transferred to HM Treasury, and the Bank's regulatory functions passed to the new Financial Services Authority.

Eddie George, Governor
of the Bank of England.

Today the Bank of England, the central bank of the United Kingdom, has three core purposes which are:-

- the maintenance of the integrity and value of the currency

- the maintenance of the integrity of the financial system, including payment and settlement arrangements

- the promotion of the efficiency and effectiveness of the UK financial sector.

✱ Core Values.

View of the Roman mosaic pavement
from the main staircase.

In the Reading Point on Level 5 West at Tate Modern, and in the Bank of England Museum, at unspecified times during the day, a randomly-selected visitor will be approached by a Gallery or Museum official. 'This is for you' will accompany the presentation of a special gift – a limited-edition print – produced by the artists. The gift will be given away several times a day for the duration of *Capital*.

Objects – while acting as tools, products, works of art or commodities – are essentially vehicles for relationships between people. In exchange, the daily circulation of things through people, it is primarily the objects' *differences* that are gauged. These differences are expressed as a value; usually as the price one is prepared to pay. However, the value of an object as a gift is not invested in its material property or its financial price, but in the mode of its giving or reception: 'It's the thought that counts'.

It was the Greek philosopher Aristotle – in *The Nicomachean Ethics* – who, by taking account of the conditions of the giver, the value of the gift and circumstances of the expenditure, was able to propose a 'magnificence in spending'. For Aristotle, giving correctly – not to one's family or immediate friends, but towards the public good – ensures that one's gifts are seen as a virtuous action. The donor so described by Aristotle is the 'connoisseur of the social'; giver of the honorific Public Gift. Such gifts dominate the economy of Tate, and – as with all gifts – are characterised by the misrecognition of the debt they entail, or, more often, the nature of the return is left unspecified. On the other side of the same coin – in an economy of value represented by the movement of money – a debt guarantees a contractual and interested return. That's why a loan is not recognised as a gift.

The gift in *Capital* is the inverse of the honorific gift. We are returning public money as a limited-edition print, to those visitors to Tate Modern and the Bank of England Museum whose contributions are unaccounted for. Theirs is not the 'magnificence of spending' but the invisible support of anonymous giving. Always and already within the web of obligations to give and reciprocate, our symbolic gift/debt activates a social contract, and will have to be repaid.

Our intention with the issue of the gift, and by extension to all those individuals that enter into its orbit – through rumour, publicity, the seminar series or this book – is to initiate an engagement with some sense of the social imagination. Indirectly, we hope to open up questions surrounding perception of value, its coagulations (as capital), its releases and consequences; to connect with the myriad pressures that move values through the otherwise distinct economies of the Bank and Tate, and out into an infinity of teeming others. 'It's the thought that counts.'

Neil Cummings and Marysia Lewandowska

IT'S THE THOUGHT THAT COUNTS

Things that have a use can be used both well and badly; and wealth is a thing that can be used. The person who makes the best use of any given thing is the person who possesses the relevant virtue; therefore that person will also make the best use of wealth who possesses the virtue relevant to wealth; and this is the liberal man. The use of money is considered to consist in spending and giving; receiving and keeping it are more a matter of acquisition. Hence it is more the mark of the liberal man to give to the right people than to receive from the right people, or not to receive from the wrong people; because virtue consists more in doing good than in receiving it, and more in doing fine actions than in refraining from disgraceful ones. It is not hard to see that doing good and performing fine actions go along with giving, while receiving good or not acting disgracefully goes with receiving. Also gratitude is directed towards the person who gives, not towards the person who refuses to take: and this is even more true of praise. Also it is easier not to take than to give; for people are less inclined to give up what is their own than not to take what belongs to somebody else. Again, those who give are called liberal, but those who do not take are praised not for liberality but quite as much for justice; and those who do take are not praised at all. Of all those who are called virtuous the liberal are probably the best liked, because they are helpful; and their help consists in giving.

Aristotle, *The Nicomachean Ethics*, c.325 BC

Pepper has been called "the gift of the East", though "gift" means poison in Swedish, don't let that put you off

I. O. U.

NOTHING

We are happy to assume that both events, gift will somehow balance themselves out so that no one receives
and
debt,

'Society always pays itself in the counterfeit coin of its dream', Marcel Mauss

In our society, how do we understand the categories of gift and debt?
Normally as things that are exceptions to the usual run. The former is
gratefully received, while acknowledgement of the latter is often avoided.
In both cases it is important not to arouse the suspicion of expectation,
and thus we place a premium on delight and innocence. This is not to
say that such events are not anticipated, as festivals of social inclusion
for example – where everything is shared – or as places dedicated to the
containment of those who are excluded from participation. Yet we do not
seem to know so much about how this happens, only the consequences.
or loses more than is his or her due, as in the phrase 'to give with one hand and take away with the other'.
The process is the basis of what we consider just. To be given too much is
to be the object of reproach, even if this is no fault of your own. Similarly,
to be heavily in debt can arouse genuine feelings of pity and concern in
others, even if the situation has arisen from your own profligacy. It is as if
everything in the world should balance out, plus and minus. In its more
pious forms it is represented as the very nature of things such that by virtue
of our existence we are born indebted and our life is a labour to pay it all
back. Hence such concepts as 'God's gift', or indeed, 'God gave rock and
roll to you'.

Jeremy Valentine

If not religious conviction, then at least anonymity protects the gift and its
debt from such forensic questions as cause, origin or purpose. Modesty and
propriety seem to prevent us from looking at these phenomena too closely,
as in the colloquial advice 'never look a gift horse in the mouth'. Perhaps
doing so would tempt more than fate and betray signs of ingratitude or of
a desire to evade one's responsibility. After all, for a recipient to demand that
the donor of a gift should explain his or her motives for this act would
destroy the unspoken and tacit assumptions on which it rests. Similarly,
to dispute whether one has incurred a debt would arouse the suspicion that
perhaps one has not understood, or, worse, is pretending not to understand,
the rules by which one otherwise plays with enthusiasm if things go well.
In such situations one can rapidly find oneself dependent on relations with
others that are mediated by a *fee*, a formal obligation to remunerate for
a service rendered, and which, if the situation deteriorates in proportion
to the scale by which further debts pile up, can in turn give rise to a *feud*.

Such a likely chain of events is not mere coincidence but is governed by
the etymology that structures these relations according to their common
Latin derivatives; *feudum, feodum, fieu, feu, fief, feof, fee-simple, feudalism.*

Although originally the notion of *feudum* probably had something to do with the ownership of cattle and the land on which they grazed, the term is now associated with a system of social organisation which we like to believe we no longer inhabit, and a pathological form of behaviour which arises to disrupt the environment that would confirm this belief. Thus *feud* denotes both land held under obligatory relations of protection and obedience and, *at the same time*, lasting mutual hostility between tribes, families, gangs, neighbours ('from hell'), football supporters, religions, businesses and institutions, and which is the inevitable outcome of the former. Even the most tactful civil servants and managers embroil themselves in turf-wars. Often the original exchange which gave rise to the dispute has been forgotten, which tends to increase the reasons for its continuation, as honour and prestige depend on self-estimation as much as recognition and are rarely derived from the facts of the case, a convention to which all parties assent.

To look at the matter more closely we can consider a spectacular dispute of this nature, still present within the contemporary popular memory. This concerns the feud between Mr Al-Fayed and Mr Hamilton which arose because the former, the proprietor of Harrods, had, via an intermediary, contracted the latter, an elected political representative, to intervene on behalf of his extensive business interests during the course of parliamentary procedure. Mr Hamilton denied any involvement and Mr Al-Fayed's accusations flew. As these alleged that Mr Hamilton had accepted the gift of hospitality it became apparent that he might have transgressed the sanctified rules of Parliament, and accordingly the law acted on behalf of itself, sentencing the disgraced MP for having lied in denying Mr Al-Fayed's claims, which for their part were supported by receipts.

Although the fees that the case generated are difficult to estimate, the ramifications of the scandal are well known. What is often overlooked is the plight of the unfortunate Mr Al-Fayed. As Mr Hamilton undertook an obligation which legally he could not fulfil, there is no public arena or convention through which Mr Al-Fayed could obtain recognition. Yet the grievance runs deeper as Mr Hamilton's failure to honour an obligation to Mr Al-Fayed undermines the latter's claim to participate in relations of trust and reciprocity that are prior to any simple exchange of equivalents, or what in such circles go by the euphemism of a 'gentleman's agreement'. The denial suggested that Mr Hamilton regarded Mr Al-Fayed as of no consequence *socially*, and thus lacked the power to place him under an obligation and relation of dependence. Indeed, Mr Al-Fayed's insistence

Obituary
By the death of Sir Henry Tate, who passed away at his Streatham residence on Tuesday, at the ripe age of four-score years, a munificent benefactor to the nation, in the interests alike of science and art, has been removed. Much of the great wealth derived from a long and prosperous business career was freely bestowed upon the public. His gifts to University College, Liverpool alone amounted to over £50,000. He built and endowed a Homoeopathic Hospital in the same city at the cost of £30,000, subscribed £10,000 to the Royal Infirmary and endowed numerous educational scholarships in the district. The Building Fund of Owens College, Manchester, received from him £10,000. London was enriched by him with the Gallery of British Art, built in 1895-7, and opened after enlargement at the donor's expense a fortnight ago, and to which Sir Henry Tate also gave four of Millais' best works and other fine examples by Watts, Orchardson, Waterhouse, Alma Tadema, Leighton, Gow, B. Rivière, Keeley Halswelle, and others, the building and these paintings representing a money value of at least £160,000. He also built the Central Library at Brixton at a cost of £15,000, and similar institutions in South Lambeth Road, Streatham, and West Norwood, the architect of the Tate Gallery, and all the public libraries just named, being Mr. Sidney R.J. Smith.

The Building News, 8 December 1899

on protesting a grievance after the case was settled as well as it could have been may well constitute a form of *social* crime, as if the expectation of reciprocity was based on the claim to a right which was held fraudulently, as if it had been purchased. In this light Mr Al-Fayed's exclusion from the enjoyment of such rights becomes justified on the basis of his attempt to claim them, as if he were an unwelcome guest who had abused the hospitality extended to him.

In our society delicate matters such as these are regarded with the utmost sensitivity and caution and are handled by specialists who effectively subdue the feud by adding further costs to its prosecution and defence. This is perhaps one of the things that makes us modern, in the sense that conduct is administered and accounted. But is there any substance to our modernity? Here we can compare ourselves with those historical social forms from which we often claim descent. Beginning with the Greek city-states, and progressing through the rise and fall of the Roman Empire up to the triumph of the Christian Bishops and beyond to the institutions of alms and charity, the gift and the debts of obligation and dependence it entailed was a matter of visible public Giving was a competitive matter through which one displayed one's virtue, and thus one's possession of the authority to occupy the position to accumulate what one subsequently gave out, and thus to exploit the debt it created. Needless to say, public office was a very expensive business as who is to decide whether one has given enough, or where the debt is greatest? Whether one thinks of the endless intrigues around the constant feasting and presenting of *The Odyssey*, of Aristotle's extolling the noble virtue of *magnificence*, or even Ridley Scott's spectacular re-creation of the politics of *panem et circenses* in *Gladiator*, one is aware that generosity did not arise through the pursuit of some higher end, but through the requirement that complex relations of hierarchy and prestige be maintained.

Perhaps we are less distant from these lifestyles than we would otherwise like to admit, and thus, in a sense, indebted to them? One could easily make pop sociology comments about a Tyson or a Beckham, or the hidden systems of grace and favour which sustain our so-called elites, or even the economy of objects manufactured solely for the purpose of giving and receiving, but the more substantial point concerns the very categories in which we think. According to the linguist Émile Benveniste, who recognised that language is a social fact, the common Indo-European roots of giving are indistinguishable from taking by dint of 'a curious semantic ambivalence', for example in the nominal forms and their suffixes derived from the Greek '*dō-*'. Consequently, giving is indistinguishable from the obligation to return, and thus debt.

≫→

concern because the existence of the public itself relied on it.

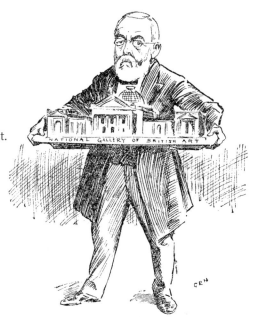

The Prince of Wales to Mr. Tate: "I thank you extremely for having asked me to come here to-day; and may I be bold enough to say that in the name of our entire nation we thank you from the bottom of our hearts for this munificent gift?"

A commodity appears at first sight an extremely obvious, trivial thing. But its analysis brings out that it is a very strange thing, abounding in metaphysical subtleties and theological niceties. So far as it is a use-value, there is nothing mysterious about it, whether we consider it from the point of view that by its properties it satisfies human needs, or that it first takes on these properties as the product of human labour. It is absolutely clear that, by his activity, man changes the forms of the materials of nature in such a way as to make them useful to him. The form of wood, for instance, is altered if a table is made out of it. Nevertheless the table continues to be wood, an ordinary, sensuous thing. But as soon as it emerges as a commodity, it changes into a thing which transcends sensuousness. It not only stands with its feet on the ground, but, in relation to all other commodities, it stands on its head, and evolves out of its wooden brain grotesque ideas, far more wonderful than if it were to begin dancing of its own free will.

Karl Marx, 'The Fetishism of the Commodity and its Secret', *Das Kapital*, 1867

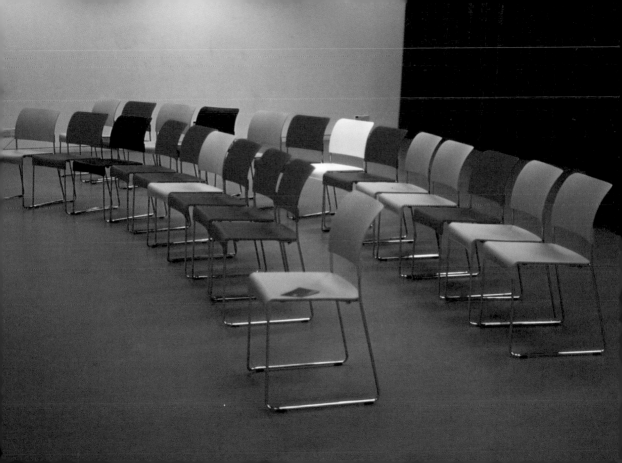

If we selectively condense Benveniste's complex narrative, which shows, amongst other things, that 'expense' is indistinguishable from 'loss', two discoveries are of utmost relevance for us. Firstly, the notion of exchange derived from *munus*, and which is in turn derived from the Indo-Iranian notion of *mitra*, the cosmic contract of reciprocal rights and obligations, is the basis of public spectacle and favour and the obligations these entail. 'The word contains the double value of a charge conferred as a distinction and of donations imposed in return'. It is the basis of community, the sharing of such obligations which must

Whether Marx used this distinction as a principle of interpretation and moral criticism in order to reinstate the community which liquidates it, or whether it was in fact an accomplishment of the capitalist society which Marx described, is a moot point that is unlikely to be resolved.

Yet Marx's argument was limited in its approach to time, which was only thought in terms of the time of labour. It is through the suspension of immediate relations of reciprocity that credit arises. The time of exchange becomes a commodity to be calculated and invested, the promise of the capitalist enterprise. Indeed, so central is time that a speculative economy has arisen around it on which our futures depend in the form of the pension. Despite the charts and equations and diagrams this future is ⋙⟶

be generous rather than calculated. And thus also of municipality, the spatialisation of distinction, communism, its abolition, and communication; the very technology by which any and all of this will take place. Secondly, the notion of value refers to both intrinsic worth and the comparison with an equivalent, and is thus prior to Marx's famous distinction between use and exchange.

essentially a labour of the imagination, as the current revision of predictions confirms. Arguably, if Marx was serious about communism, then this dimension of time is what is missing from the formula 'from each according to his ability, to each according to his needs', a fact that became apparent to those who tried it.

The importance of the time of exchange was discovered by Marcel Mauss, the anthropologist who inspired Benveniste's research on the semantics of exchange, in the notion of *potlach*. This is a communal festival in which the community is affirmed by the consumption of the resources on which it relies, and which in their production organises the social relations of the community itself which *potlatch* destroys *in order for such relations to be re-built*, thus giving purpose to the labour of production itself. *Potlatch*, which may be a universal fact of humanity, is the institutionalisation of the time of the gift. It constitutes a form of expenditure without return, and thus something which is in fact impossible; namely, a pure gift which cannot be exchanged for the obligation that it immediately entails. *Potlach* is *un-economic* because everything is given out, guaranteeing that there is nothing left to invest and thus that we will come together to produce what we need, and which are primarily our relations with each other. After all, if you have enough, why do more?

The sociologist Georges Bataille was so impressed by this idea that he regarded the Marshall Plan, the US financed system of European social and cultural re-construction which followed the last world war, as a contemporary version of *potlach* which was sustained insofar as 'actually existing socialism' presented itself as an alternative. Within the Welfare system which characterised the European State the approach to the gift was more sanguine and straightforwardly altrusistic, and this allowed for discrimination between who could and could not give, as well as providing a less destructive reason for giving in the first place. This is the basis of Richard Titmuss's classic defence of the non-market approach to blood transfusion, which also drew on Mauss. The specificity of the gift of blood under welfare is that it circulates in a system designed to ensure that donor and recipient are unknown to each other. Thus personal gain and sanction is eliminated and quality can be strictly monitored. The gift of blood is pure in the sense that no reward or obligation is produced through it.

Yet at the same time trust, reciprocity and obligation is transferred to the system that collects and distributes the blood. The health of the blood is the health of the system which ensures the health of the community. In this respect the system acquires the status of an original gift on the basis of which it acquires moral authority.

As we know, the moral status of the system has become a qualitative cost that it is increasingly unwilling to bear, precisely because it is incommensurate with the quantitative costs which are required to support it. As we also know, the consequence of this has been the voluntary contracting out of both donors and recipients, as well as those who make the system run, in a context in which not only is dangerous blood in circulation, but also semen, organs and the elementary codes of life itself. This raises awkward questions in which ethics,

biotechnology and economics are increasingly synthesised. For example, do we have a form of belonging which can acknowledge our potential dependence on the living organs of the dead? Or by the same token, is such a dependence a symbol of our non-belonging with each other, our non-community? Through these questions a different relation to the future opens before us.

However, in a sense we have only described the surface of things, the way things should run smoothly. We only know of this when the system breaks down or is interrupted, as in Tony Hancock's famous calculation that a pint of blood is almost equivalent to an armful of blood but is not equivalent to a cup of tea and a biscuit as far as he is concerned. In other words, we have only discussed the official side of things which resemble a structure of actions that can be administered. In practice, things are not what they appear to be, as Mr Al-Fayed found out. According to the sociologist Pierre Bourdieu:

'Gift exchange is one of the social games that cannot be played unless the players refuse to acknowledge the objective truth of the game, the very truth that objective analysis brings to light, and unless they are predisposed to contribute, with their efforts, their marks of care and attention, and their time, to the production of collective misrecognition.'

This game is the morality of the gift through which its misrecognition

as something that is free is sustained. Mr
Al-Fayed's *social* crime was to invest
in the misrecognition even though he
recognised it as such. That is to say, even
though you give me a CD and I give you
a pair of socks we still have to get through
the Christmas schedule together even
though both of us know that these
objects are not equivalent, precisely
because doing so is symbolic even if our
friendship or other tie is suddenly not
worth very much.

This agreement is neither the effect
of conscious intention or automatic
calculation but is the recognition that
what holds us together is the game
through which we exercise power over
each other, and which therefore depends
on the possibility of loss in order to
motivate our belonging in debt. This
need not be done immediately, and the
longer the delay the more our community
is sustained. By the same token, delay
may test patience by presuming a
commonality where there is none, or
where only the debtor thinks that there is.
For example, if I respond immediately
to an obligation it may be taken as an
indecent haste to be free of the
relationship, and thus ingratitude, as
if my involvement compromised the
estimation that I have of myself. *At the*

same time, undue delay may be regarded as the inflation of a commodity I do not possess, or at least, have no right to enter into the system of equivalencies in which the relation exists, namely time. And thus betrays a desire to get ahead of my status at the expense of the other, as acceptance of the delay would in practice constitute recognition of the status to which I aspire. Anyone who has not had a call returned, or has not returned one, will know what I mean.

In other words, to receive a gift from someone who sets no limits on the time of return and who does not designate the token with which this is to be done is to enter into a relation with someone who either fancies themselves omnipotent or is an abject social climber. In the first case acceptance of the gift effectively condemns one to bondage. In the second case to conspire with the flattery would be to give something one does not have before one receives something that can never be consumed. What makes us modern is that there is no independent objective measure available to us through which this matter could be decided in order to distinguish one from the other, or to tell the counterfeit from the real thing. Hence, perhaps, our modern prudence arises from the fact that no one, or no thing, presides over our exchanges. The gift is a risk.

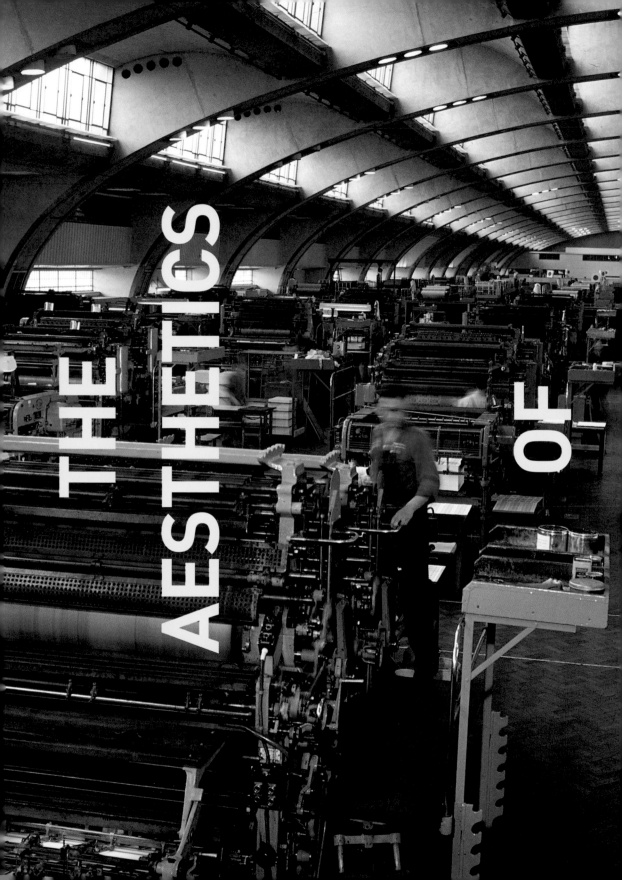

An image I cannot get rid of is that of a newborn infant having its face pressed to the earth before it has drawn breath. The imperative was once so overriding that even a woman without surviving children might suffocate her baby. I cannot get rid of the image because of the reason. It used to happen (so it was alleged) not because the woman had no wish for a child, nor because the child was malformed or there were too many mouths to feed or the birth was illegitimate, but because of its identity. No. I am wrong in one particular. We are told that the child was malformed; its misfortune was to be large. Now everything that one is taught to think about health and infant mortality makes the converse, the desire to have fat babies, unexceptional. So whereas I might find it, at the least, comprehensible if circumstances led to the mercy killing of a puny child, no amount of comprehension will subdue the bonny picture I put together. I cannot 'see' the mother's desperation; it is covered by everything conveyed in the description of the apparently healthy infant. But no, the fat baby born to the luckless mother was not healthy at all, or at least not for others. Such children were witch-children, identified by a special name. And they presented the evidence in themselves: they were witch children precisely because they were fat.

Disposal

The sociologist Rolland Munro asks how we rid ourselves of unwanted images. For him, this is part of a larger problem about the disposal of meaning. He is speaking of a (Euro-American) world where the production of meaning seems endless, and its excess almost effortless. When asked to talk about the significance of bark paintings, the Yolngu (Australian aboriginal) artist Naritjin replied: 'There are too many meanings. Later on, when you know more, you'll know which ones to choose and which ones to discard.' How is that discarding done? The conundrum, choosing what action to bring into play that will not itself add more meanings, has its own twist: the need for dispersal under pressure of excess. How, then, does one set about disposing of meanings, getting rid of images? One of Munro's answers is to point to the fact that, mercifully, meanings are

Marilyn Strathern

SUBSTANCE

A NOTE ON THE TEXT
This extract is taken from *Property, Substance and Effect* (1999), which deals with contemporary issues in property relations, and excess is one if its themes. 'If the world is shrinking in terms of resources, it is expanding in terms of new candidates for ownership; there are at once new kinds of entities being created and new grounds for property – among other types of ownership – claims. Whether one lives in Papua New Guinea or in Britain, cultural categories are being dissolved and re-formed at a tempo that calls for reflection, and that – I would add – calls for the kind of lateral reflection afforded by ethnographic insight' (*from the introductory chapter*).

What is revealed in all this is the author or artist's very ability or capacity to be continuously productive,

often pre-disposed by social convention.

But let us think of those circumstances when attention is drawn to the qualities being conveyed by an image: the point is that anything recognised as an 'image' is recognised as being offered for or as explicitly requiring an act of interpretation. Images are meanings made available, we might say, for consumption. Rhetorical productions – the arts, literature – bring home the point, however, that the effect of an image depends on the extent to which persons are willing to assimilate it. But does such assimilation diminish or instead increase the quantity of 'meaning'? Meanings are not taken 'away' from the performer or artist or author; indeed they may be extended, turned and amplified by the audience. In any case images may have to be re-produced over and over again in order to satisfy consumers looking for particular meanings.

which would in turn only seem to increase the problems of excess. It would imply that in addition to meanings one might have to think about creativity itself as a subject for disposal. If this seems too excessive an extension of the meanings to be found in the concepts of production and consumption, let me evoke a set of social circumstances which could almost have been designed to answer the question about assimilation. Here the producers and consumers of images not only may, but must, come face to face: the persons are made present to one another. And under these social arrangements assimilation can work as a disposal of a kind, as though people deliberately put themselves into the position of extracting – draining away – meanings from one another. Two examples from Papua New Guinea are pertinent. The social arrangements in question concerned the flow of 'life-force' which Etoro men circulated among themselves and the ceremonial exchanges through which Hagen men circulated wealth. In both cases, men knew they had to seek recipients for their creativity. In the former, it was creativity itself that was circulated and consumed by others; in the latter, men kept the sources of creativity but circulated its products. In the late 1960s the anthropologist Raymond Kelly embarked on an extensive study of the Etoro people of interior Papua New Guinea. The story of the smothered child comes from his ethnography. My own initial work in Hagen dates from roughly the same time. The reader does not need to know the broader cultural background to either Hagen or Etoro in order to appreciate the points that follow but does need to know that much of the material is historical.

Now Munro asks about unwanted images. When, as he says, meanings are to some extent pre-disposed by social convention, as seemingly applies to the fat body of the witch-child, by getting rid of the image then you can at least get rid of a thing to which meaning fastens. The desire is to ≫→

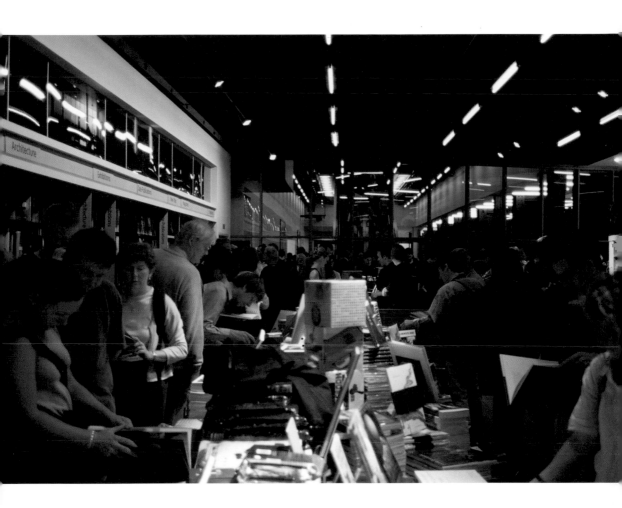

be rid. But I have wished to put this into a context where the desire to be rid of something may be realised for positive as well as negative reasons. One might wish to dispose of things because it is only by peeling off the products of creativity that fresh, creative acts become possible. If others are construed as wanting these things, then evidence of creativity can be made to rest in the satisfaction of their desire. Both Etoro and Hagen men produced (the products of) creativity in already consumable form, for an audience or recipient, creating images intended to be lodged in other people (minds/bodies). And the audience or recipient, however coercive the act, invariably agreed to consume the product. That is, the image was not ordinarily refused. It could only be refused by breaking off relations between the 'producers' and 'consumers'. We might say that this is exactly the Etoro mother's dilemma. She could not discount the evidence of witchcraft before her eyes. She could, however, refuse to be the creature's mother, that is, refuse to activate the relationship.

But beyond agreeing or refusing to consume is the problematic nature of consumption itself. An anthropologist might add that the tragedy of the Etoro witch-child lay in those very practices, the social work, that disposed of meaning in other contexts. For they created the possibility of imagining another type of consumption altogether, consumption that had not disposed of creativity but had instead accumulated it. Etoro put together a horrifying picture of a person not dissipating but hoarding the vitality of others. This is what witches did. And the witch child reduplicated the identity of its witch parent(s), at once the outcome of excess and an embodiment of excess. Not itself available to absorption or consumption by others, the image had to be eliminated by different means.

THE QUESTION OF SUBSTANCE
Etoro

Etoro used body size as an image that could be passed between persons. As in places elsewhere in Papua New Guinea, men's universe was predicated on the supposition that the senior generation in effect bestowed their bodies on the junior generation. Younger men absorbed the life-force (*hame*) of older men in this way.

It was thought that life-force, which was regarded as in finite supply, should not lodge too much in any one body. Rather, it had to flow, and Etoro men kept it in constant circulation in the form of semen donation, meat provision (growth-inducing food) and the distribution of shell valuables (wealth) that were signs of vitality. Men were able to track the enlargement and depletion of this life-force in their relations with others. Over a lifetime, they thus moved from being, in adolescence and early adulthood, recipients

of other men's life-force until the moment in their prime when they themselves became donors, and as donors, in middle and later years, continued to bestow it on juniors in turn. Life-force was transmitted to the unborn child through sexual intercourse, to boys through insemination (this is what initiation was about) and to others generally through transactions with shells and meat whose giving was regarded as equivalent to insemination. Hence, in adolescence and early adulthood, men built up repositories of this life-force while, as they moved into the middle years, their own force subsequently became depleted at the expense of the new generation growing up behind them. As their bodies withered through this process, depletion became a source of pride.

As beneficiaries of other men's acts, men who received had also to give. For a man to give there had to be an appropriate recipient: initiates and wives to inseminate, receptacles

for the life-force thereby bestowed. The willing recipient was crucial to sustaining this flow and, in the case of men, became a donor in turn. Witches, however, men and women alike, snatched rather than received and as a consequence could never get rid of what accumulated inside.

Witches first attacked and then consumed their victims, the size of their bodies becoming a mark of this engorgement. Because their very soul was in a transmuted state, they could never get rid of this predisposition to harm others, until, that is, they were killed themselves. The witch-child 'inherited' the same transmuted soul without, it would seem, any diminution to the witch-parents' capacities.

Etoro conceived of the witch hungering after the victim, yet it was not food as such that filled out the flesh, and for all that the witch-child replicated its parents, it was not the transmission of physical tissue in this case which was significant. Etoro did not interpret the growth and form of persons as a direct consequence of the physical ingestion of ordinary food. Although Etoro persons were regarded as composed of hair, flesh, bone and blood derived from their parents, and although the witch's body was a manifestation of greed, these effects were – as I would phrase it – merely a secondary presentation or shadow of the 'primary' or 'inside' body. This primary body was invisible, a 'spirit double' the ethnographer called it, and this was the body nourished by its own activities, which grew and decayed, which was cared for by lineage spirits. It was also the body that committed and succumbed to witch attack. Ever present, it shared with its secondary condition, the corporeal 'outside' body, the capacity to be filled and emptied of life-force. The witches' problem was that they filled but could not empty themselves; the state of their soul prevented that.

Witches fed invisibly on their victims; in eating the inside limbs and

organs of the primary body they consumed the victim's life-force. The swollen secondary body that Etoro pictured to themselves was an image of this hidden process – not a representation but the imago, evidence, a mask pressed on the face of the real thing. This visible 'outside' body, the image, had an aesthetic effect for it communicated this condition to others. But that was all it did. For what was made evident in a witch's body was also true of bodies generally. In Etoro eyes, flesh did not itself have the capacity for growth; food was not nourishment in that sense. It was life-force that caused growth, which filled out a person and was passed on across the generations. Life-force was not otherwise transformed into other things: it simply came to exist in greater or lesser quantity in its capacity to fill and empty a person's (two) bodies. However, and the witches drew attention to it, this life-force could assume a form; as an image it was made material.

By material I mean that it became the subject of people's interactions and thus a quality attached to their relationships. We have seen that in general life-force lodged in the bodies of both donors and recipients. It was made material when it thus passed between persons – as an actualisation of the act of transfer or donation. Persons as they appeared to the eye were, in this sense and in themselves, images of transactions. Giving and receiving: that is what the outside body conveyed. The outside body was at once an aesthetic medium for the effect persons had on one another and the enactment of that effect. Relationships, in short, provided the material conditions for life, and in the normal course of events, excess never built up. At the same time, flow was one-way. It was because specific persons in specific relations were there that an Etoro man could move over the span of a lifetime from a condition where he lacked life-force to one where he was visibly grown by it to a position of visible depletion. This was the aesthetic movement: the receiver of the messsage, the consumer of the body, inside and outside alike, was the one who registered its effect. In assimilating the producer's body, he or she also drained it, and thereby enabled its form literally to conform to a cycle of increase and decrease in which it would appear – and ought to appear – at the end of life as 'small' as it did at the beginning.

Hagen

I turn now to a society where enlargement and depletion in the presentation of persons were imagined as an alternation of states, indeed specifically orchestrated through exchanges which depended on wealth given away subsequently returning to an original donor. The flow between men was two-way. Depletion had positive overtones when it referred to wealth already dispatched. But to be thin in body before one was old indicated an inability

to attract it back again. However much he gave away in ceremonial exchange engagements (*moka*), a man's body size was expected to remain in an undiminished state. Here we could say that the images of transfer were detached from the capacity for life and presented as though they had a materiality of their own – that is, wealth was seen as mobilising relationships. There was a different tenor to reproduction: disposal occured without diminution. I would suggest that this was accomplished through a specific invention, the invention of 'substance'. Bodies were transacted between persons, so to speak, not in terms of the flow and ebb of life-force but in terms of the substance of which they were made and parts of which they could always give away.

If it were not for the Etoro, there might be no surprise to the fact that the people of Hagen prized fat babies. But the Etoro ethnography suggests that we need an explanation. Maternal anxiety surfaced when labour was prolonged and difficult; a puny child was a sign of ancestral disfavour for which the mother might suffer or incubus who had revealed itself as a spirit changeling. Its lack of substance was the problem. Hagen growth was not attributed to a 'life-force' but to what the 'inside' body made consumable (the fertility of the soil was consumed by the mother in the form of food and evinced in her milk) and turned into 'outside' images of itself (a fat child fed off fertile land). The soil made food grow, food gave bulk and strength to parents, mothers nourished children with their milk. These substances were also parts of one substance, 'grease', as visible in the pigs (themselves wealth items) which people reared and exchanged as it was in persons themselves. At the same time, such substance indicated if not a life-force then a creative capacity (nutrition, fertility), one best captured perhaps by the English epithet 'procreative'.

A Hagen child had to show a proper state of nourishment. But maternal anxiety was not only about the state of the child; it was also about the mother's capacity to bring the child forth and not retain it within. It had to be detached from her, and posed life-threatening consequences if it could not be. Men showed a similar preoccupation in their efforts to elicit wealth from others. For them, what was at issue was the demonstration of their creativity in relationships.

If for Etoro men we imagine that the subject of transfer was a capacity for life, then we might say that Hagen men by contrast used their relations to materialise the specific capacity for transfer itself. That is, they used relations to create relations. 'Substance' in the form of fat bodies and plentiful pigs or shells was evidence of this creative move. Men sought to create (sustain and innovate on) relations primarily through the flow of wealth (those pigs and

shells). What was thus revealed to be given away, taken outside, was not the growing power of a life-force but the growing power of a particular capacity – the very ability to give and give again. It followed that every enactment could only exemplify or augment that capacity. For what was given away were images of that capacity in the form of detachable substance: the wealth one produced not the power to produce it. That power remained intact. Indeed, it was furthered by the social consequences of gift giving; all such gifts stimulated counter-gifts later, so that theoretically speaking the more one gave the more one received. The image now embedded in another would be returned at a future date.

In being brought forth, the created items (food, wealth, children) were thus separated from the fertility that gave birth to them. They could be separated without radical diminution of that capacity. Thus parents bodied forth their vitality in the child, but the vitality, the capacity, the body effort, was not itself bodied forth. Rather, the child gave evidence of having received that vitality in its substance, its nourished state. Hagen nutrition, like procreation, like the drawing of wealth to one's house, did its work off-stage. And had to be kept off-stage to work. This introduces a particular set of social conventions for the disposal of images.

Etoro bodies – inside and outside – fell away and become wasted when their vitality was passed on to and thus consumed by others. In the Hagen case, the disposed-of body became only temporarily 'wasted'. In the foregrounding or separation of an outcome (wealth) from its origin (the donor), what dropped off, the discarded image of the donor in his glory, might also be thought of as being momentarily hidden from view. That is, the entities out of which others were brought forth become backgrounded. The cavity of the men's house from which shell valuables came was closed up after the ceremony. It was because the detached element (e.g. the shell) came to stand for the whole process, and thus referred to, encapsulated or exemplified its own origin, that what had once been its origins were now parts located 'elsewhere', and thus concealed. However, Hagen men did not just force others to act as recipients of what they produced; they also disposed of these images by rendering them invisible, for valuables such as shells, once handed over, were hidden away in other men's houses. In the same way, if they were not actually eaten, pigs which had come from the privacy of people's domestic spaces went to those of others. What had been revealed was the very capacity to make things appear in such a mode that they could be detached, and passing them on to others was a means of further concealment. What was kept concealed was growing power, regeneration. Generative capacity was retained (to create more relations) and what was passed on, made material through the relations which elicited them, were the crucial images of detachment which kept up the flow of persons and wealth.

In visualising these flows as flows of substance, Hagen men gave themselves a significant purchase. If Etoro men only wanted life-force to lodge in them for a while, and then pass it on, glorying in the evidence of their own diminishment, they took a lifetime to do it. Hagen men could speed up the process in their circulation of exchange items: they, too, only wanted the wealth to appear at certain times, although in this case what they gave out also came back on subsequent occasions, an enactment of their own continuing capacity for growth which enabled them to repeat the transactions and thus keep substance flowing. Therefore, although giving was a highly creative act for the donor, he could not do it alone. The act required the materialisation of social relations, real time and real people, other persons prepared to act as recipients. That is, the special occasions of ceremonial exchange were predicated on a rhetorical need: there had to be someone who came and demanded the wealth.

Velocity

One might describe the presentation of bodily increase and decrease of life-force (Etoro) and substance (Hagen) as follows: Men pressed onto others the consumption and thus *disposal* of what they were, as a consequence, seen to embody. This body/wealth was intended to be interpreted as the product of creativity, which thus existed already in the discourse about it, that is, in the capacity to produce descriptions for others to consume. Involving others has its consequences. One obvious problem is that it subverts the communication of intention, since – as Papua New Guineans tirelessly tell themselves – everyone has their own (intentions). Moreover, social engagement taken to excess can also pose serious problems for disposability. That is because the number of people who can be enrolled in an enterprise contribute to the velocity with which things circulate.

In their staged disposal of what they produced, Hagen men entertained the idea of constant expansion, that they could always extend their relationships. One of the 'illusions' of wealth, we could also say this extension was an illusion of disposal. Ever more conduits by which to get rid of wealth and ever more relationships as a result. They were constrained of course by having to gather together the resources and persons to make a show, but then we might also say that their ability to dispose of wealth was constrained by the wealth they stimulated to flow towards – not just away from – them. What appears to have been important, and the subject of aesthetic discourse, was the need to keep the two-way flow moving. The possibility of increasing the flow of wealth was in part a matter of velocity, the speed at which items circulated.

Writing of the 1980s, the anthropologist Eric Hirsch commented on the place that ritual had come to occupy in the world of the Fuyuge, another Papua New Guinean people. It was not the case that their ritual performances had nowadays become irrelevant, 'but that [they] must be performed at a more rapid pace – [they] need[ed] to be speeded up'. This description matches the kinds of uses to which money was being put in Hagen in the 1960s, and even more evidently in the 1990s.

Money has an elicitory capacity of the kind Hageners readily appreciate: it can draw forth and detach a whole range of things from persons. Money speeds up transactions. I have suggested that Hagen exchange practices realised some of the potential of velocity; in despatching goods that return, one short-circuited (so to speak) the cycle of growth and decay which Etoro took a lifetime to accomplish. Handing over gifts of money in turn short-circuits cycles of production and transaction. At the same time money can make accumulation and dispersal visible, and thus becomes 'visible' itself. For Hageners the subject of endless discourse, a constant source of amazement, is that money does both: people wonder at the size of what they can collect together, as when a clan makes a major purchase, and wonder equally at the way it disappears, when they are left as they say with no money on their skins.

Today its seemingly ubiquitous presence has become a measure of both the past and the future. Of course Hagen men and women comment by saying there is not enough of it. But in their imaginations, that is, when it is in their wallets, money can do anything and anything can be turned into it. And they complain of this ubiquity: it is, in a sense, in too many places. People buy favours with it, leave home for it, sell their heirlooms for it – and keep it from others. Money has become visible all the time, a medium whose enabling capacities cannot be hid. For money that can be stashed away so easily is in another sense hard to hide. It is hard to hide in other persons. And there is a new reason – not the reluctance of the recipient/consumer forced to accept what he is given but the reluctance of the donor/producer unwilling to give it away. An image of pure transfer, one might say, money at once makes too many things flow and does not itself always flow properly. It becomes only part-detachable.

At once invested with intrinsic value and excessive in its influence, money poses something of a conundrum. It exerts pressure precisely just as one might imagine the excessive influence of 'meaning'.

Munro's concern with the disposal of meaning came from his critique of certain theories of consumption. There is no end, he writes, to the consumption theorist's ability to theorise and spin meaning. However, the Euro-American theorist's ability to proliferate meanings – for example in the analytical writing of academic papers – does not in itself require specific ⮞⟶

On one of these occasions, when they had both been perfectly quiet for a long time, and Mr. Dombey only knew that the child was awake by occasionally glancing at his eye, where the bright fire was sparkling like a jewel, little Paul broke silence thus:

'Papa! what's money?'

The abrupt question had such immediate reference to the subject of Mr. Dombey's thoughts, that Mr. Dombey was quite disconcerted.

'What is money, Paul?' he answered. 'Money?'

'Yes,' said the child, laying his hands upon the elbows of his little chair, and turning the old face up towards Mr. Dombey's; 'what is money?'

Mr. Dombey was in a difficulty. He would have liked to give him some explanation involving the terms circulating-medium, currency, depreciation of currency, paper, bullion, rates of exchange, value of precious metals in the market, and so forth; but looking down at the little chair, and seeing what a long way down it was, he answered:

'Gold, and silver, and copper. Guineas, shillings, half-pence. You know what they are?'

'Oh yes, I know what they are,' said Paul. 'I don't mean that, Papa. I mean what's money after all?'

Heaven and Earth, how old his face was as he turned it up again towards his father's!

'What is money after all!' said Mr. Dombey, backing his chair a little, that he might the better gaze in sheer amazement at the presumptuous atom that propounded such an inquiry.

'I mean, Papa, what can it do?' returned Paul, folding his arms (they were hardly long

enough to fold), and looking at the fire, and up at him, and at the fire, and up at him again.

Mr. Dombey drew his chair back to its former place, and patted him on the head.

'You'll know better by-and-by, my man,' he said. 'Money, Paul, can do anything.'

He took hold of the little hand, and beat it softly against one of his own, as he said so.

But Paul got his hand free as soon as he could; and rubbing it gently to and fro on the elbow of his chair, as if his wit were in the palm, and he were sharpening it – and looking at the fire again, as though the fire had been his adviser and prompter – repeated, after a short pause:

'Anything, Papa?'

'Yes. Anything – almost,' said Mr. Dombey.

'Anything means everything, don't it, Papa?' asked his son: not observing, or possibly not understanding, the qualification.

'It includes it: yes,' said Mr. Dombey.

'Why didn't money save me my Mama?' returned the child. 'It isn't cruel, is it?'

'Cruel!' said Mr. Dombey, settling his neckcloth, and seeming to resent the idea. 'No. A good thing can't be cruel.'

'If it's a good thing, and can do anything,' said the little fellow, thoughtfully, as he looked back at the fire, 'I wonder why it didn't save me my Mama.'

Charles Dickens, *Dombey and Son*, 1847

theories. Theorists' dominant medium, writing, like money, does it for them. Detachment would seem easy enough – in publications, papers, conferences. But the form of publication also means that meanings are left visible, exposed. One cannot get rid of meanings by hiding them. Anthropologists devise models (restrictions) to control the need to take into account everything they have laid out. Yet the most elaborately layered account can still end up as excess, accumulation, the repeated evidence of past imaginings; one cannot hide what has been brought to the surface. Ever greater effort is required to encompass meaning by meaning, only to discover that constructs which appear to be offered freshly for the reader's attention in any case, already, inform the text. That revelatory device in turn points to further deferral, to future revelations. This is creativity of a kind. However, while the revelation that the terms were there all along might work as a momentary discovery, if they cannot be concealed again they cease to work as discoveries at all. Most of the time this hardly matters; yet writers do sometimes want the discoveries to be illuminating and fresh, and thus to make evident the capacity for interpretation.

If expository practices make it difficult to hide what has been brought to the surface, there is a further long-standing social obstacle to getting rid of meaning. Or rather of being certain that one has got rid of it. Euro-American writers may have to construct their audiences as general rather specific consumers, and inevitably so when they exist as an anonymous public. So there is no particular witness or recipient; what is detached, discarded, disposed of, published, is not axiomatically lodged within a particular 'other'; there is no social category of recipient apart from the general one of reader. Writers cannot rely on effect being evidenced in terms of reciprocity between persons in an ongoing relationship. The materiality of face-to-face interchange is not there. Particular audiences may of course be found in communities of scholars, say, or sports enthusiasts, known to one another so to speak through common interests and a shared discourse. They are prey to a different kind of hazard: failure to contain circulation within the community takes away its 'face-to-face' potential.

Let us also consider the point of view of the reader. Readers are targeted for their receptiveness: one of their jobs is to absorb what is written, but without – except in the forum of explicit debate – even the possibility of registering a return.

So they have to dispose of things too. But how? Gillian Beer quotes from Don DeLillo's novel *White Noise*: 'We suffer from brain fade', argues one character, 'the flow is constant ... Words, pictures, numbers, facts, graphics, statistics, specks, waves, particles, motes. Only a catastrophe gets our attention.' What of catastrophe, then? What if readers feel themselves

at the mercy of texts? Unexpected pictures jump out. A continuing flow of argument seems insufficient to carry the scenes away. Elements of narrative lodge in the memory independently of the river of words or the scaffolding of themes.

When images stay in the mind, one cannot get rid of them by an exercise of imagination – that is simply reinforcing. Just as the reader of books is unable to return them to their creator, I cannot give the image of the fat child back to Kelly.

For its faeces are the infant's first gift, a part of the body which he will give up only on persuasion by someone he loves, to whom indeed, he will make a spontaneous gift of it as a token of affection; for, as a rule, infants do not dirty strangers. (There are similar if less intense reactions with urine.) Defaecation affords the first occasion on which the child must decide between a narcissistic and an object-loving attitude. (...) It is probable that the first meaning which a child's interest in faeces develops is that of 'gift' rather than 'gold' or 'money'. The child knows no money apart from what is given him – no money acquired and none inherited of his own. Since his faeces are his first gift, the child easily transfers his interest from that substance to the new one which he comes across as the most valuable gift in life. Those who question this derivation of gifts should consider their experience of psycho-analytic treatment, study the gifts they receive as doctors from their patients, and watch the storms of transference which a gift from them can rouse in their patients.

Sigmund Freud 'On transformations of instinct as exemplified in anal eroticism', *The History of an Infantile Neurosis*, 1917

Fidelity Fiduciary Bank

If you invest your tuppence wisely in the bank,
Safe and sound,
Soon that tuppence, safely invested in the bank,
Will compound
And you'll achieve that sense of conquest
As your affluence expands
In the hands of the directors
Who invest as propriety demands.

(Spoken) You'll be part of: Railways thru Africa,
(Spoken) Exactly! Dams across the Nile,
(Spoken) The ships! Tell them about the ships!
 Fleets of ocean greyhounds,
(Spoken) More! Tell them more! Go on!
 Majestic self-amortizing canals
(Spoken) Fires the imagination!
 Plantations of ripening tea
 All from tuppence, prudently, thriftily, frugally invested
 In the (to be specific),
 In the Dawes, Tomes, Mousely, Grubbs
 Fidelity, Fiduciary Bank!

When you deposit tuppence in a bank account,
Soon you'll see . . .
That it blooms into credit of a generous amount,
Semi-annually
And you'll achieve that sense of stature
As your influence expands
To the high financial strata
That established credit now commands

(Spoken) You can purchase: First and second trust deeds,
(Spoken) Think of the foreclosures! Bonds! Chattels!
(Spoken) Dividends! Shares! Bankruptcies! Debtor sales!
(Spoken) Opportunities! All manner of private enterprise!
(Spoken) Shipyards! The mercantile! Collieries! Tanneries!
 Incorporations! Amalgamations! Banks!
(Spoken)
 While stand the Banks of England,
 England stands;
 When fall the Banks of England,
 England falls.
 All for the lack of:

 Tuppence, patiently, cautiously, trustingly invested
 In the (to be specific),
 In the Dawes, Tomes, Mousely, Grubbs
 Fidelity Fiduciary Bank!

 From Walt Disney's *Mary Poppins*

ELSE

WHERE

For many people, the experience of the modern world is increasingly insubstantial. All kinds of things show up in ways that hardly register. They live at the edge of consciousness, half-noticed, diaphanous ...

The filmy realm of the insubstantial is expanding both because there is more of it and because we are increasingly trained to take notice of it. And as this realm expands, so it is instituting new imaginations, spirit worlds of knowledge and belief.

In all kinds of ways, these spirit worlds are just as powerful as those of our ancestors. They may not be able to be touched, but they can certainly touch our lives. They are the modern equivalent of the enchanted worlds of saints and spirits that surrounded the medieval person, worlds which the peasant was certain existed. In these more sceptical times, however, our trust is less secure. How are we to guarantee that these worlds exist? How are we to be sure that the saints and spirits that inhabit them are real? We need more guarantees.

The Growth of Insubstantiality

The insubstantial manifests itself in four inter-related ways which, taken together, form the elements of new spirit worlds. The first is the growth of what Giddens (1991) calls abstract systems. These are systems of accumulated expertise that produce 'large areas of relative security for the continuance of everyday life' (Giddens, 1991, p.133). The influence of these systems is clear but their workings are often opaque. Many such systems now exist but, as Giddens (1991, p.134) points out, the most obvious example is money:

> Modern money is an abstract system of formidable complexity, a prime illustration of a symbolic system that connects truly global processes to the mundane formulations of daily life. A money economy helps regularise the provision of many day-to-day needs, even for the poorer states in the developed societies (and even though many transactions, including some of a purely economic nature, are handled in non-monetary terms). Money meshes with many other abstract systems in global arenas and in local economies. The existence of organised monetary exchange makes possible the regularised contacts and exchanges 'at distance' (in time and space) on which such an interlacing of global and local depends. In conjunction with a division of labour of parallel complexity, the monetary system routinises the provision of the goods and services necessary to everyday life.

Yet very few of the general population fully understand the modern monetary system; even in countries like the United States 'financial literacy' is quite low. And perhaps this should not come as too great a surprise.

Nigel Thrift

After all, even the professionals who claim to know all the monetary system's twists and turns are constantly being surprised by new events and complexities. Whatever the case, the upshot is clear. For many of us, money often approximates to a natural force; a system like money sets up modes of social influence which no one directly controls and which often thereby feel mysterious, based upon a provisional trust which often lacks moral life. This insubstantiality is only boosted by the sheer complexity of many abstract systems, a complexity which is so twisted and tangled that it cannot easily be represented: who could visualise all the travels of even a single five pound note in its lifetime, let alone all these journeys grossed up? Systems like money therefore become the equivalents of the worlds of spirits, parallel realms of action which mist up our everyday life in various ways by redefining what we can count as near and far.

The second way in which we have become increasingly aware of and attend to the insubstantial is through the growth of new media. Media that have made a number of elements of life at the edge of our perception into representable entities. In particular, there are all the worlds which have been revealed by the invention of new instruments of representation. We know of these worlds through these intermediaries that spirit them into being, but, once discovered, these worlds then move into a more general cultural circulation. Think of the microscope showing up the world of the infinitely small (Amato, 2000). In turn, the microscope was able to become 'an epistemological and educational tool for revolution. By changing our level of perception, it was meant to turn our values, to convert our interest from the mole hill of material surfaces to the mountain of immaterial depths' (Stafford, 1991, p.356). Or think of the telescope, showing the largeness of the Universe, and also allowing all kinds of lessons to be drawn about humanity's place in it (Ede, 2000). Nowadays, a different kind of instrument has become culturally central. This is software. Software is generally invisible in everyday use but it has a tangible interface of screen, keyboard and mouse which ties it back to the body and which allows us to visit many worlds at once with minimal physical effort. The interface allows us to double-click from world to world through what Löfgren (2000) calls the 'microphysics of movement', minute movements of eye and hand. And, in turn, this emphasis on micro-movement is being built into our culture. For example, software increasingly has the capacity to represent the body through our interactions with it: it can count keystrokes, systematically recognise facial expressions, analyse voice patterns, even recognise different smells.

Then, there is a third way: the new media can generate new forms

Re Power News

Bank notes for summary

3 col × 2³/₄

$5\frac{3}{8} \times 2\frac{3}{4}$

of imagination of the insubstantial. Benjamin's notion of film as tactile apperception is an obvious example here: 'the painter maintains in his work a rational distance from reality, the cameraman penetrates deeply into its web' (Benjamin, 1969, p.233). More generally, cinema conjures up and manipulates a spirit world. Moore (2000, p.163) goes so far as to argue that

> the camera is our one magical tool flush with animistic power to possess, enchant, travel through time and space, and bewitch. In the light of this, our theoretical superlatives about the cinema are akin to the child looking furtively beyond the curtain or checking out Santa's beard – or to confirm that there is such a thing as magic. The question of the degree to which cinema affects real life, like the issue of whether or not magic really works, is moot. The point remains that we, now, do not work without it.

Since the first magical visual effects were created by cinema, this realm of special effects has expanded out (no wonder that one of the leading contemporary firms is called Industrial Light and Magic). Not only has the increasingly computer-generated construction of special effects become a crucial element of the success of many films, but these effects have also moved through many different media; the paramount importance of effects in most computer games is a case in point. And these effects become ever more sophisticated, playing to a wider and wider range of the senses and able to call on more and more theoretical understandings of the perception of movement.

But there is more than this. These forms of magic also increasingly engage all the senses. They are no longer purely representational but have sunk into the body's knowledge of itself, as practical schemes, as the fuel of emotions, and as topological constants. And, in turn, these knowledges can be re-excavated and put to work. Lury (1999), for example, points to the crucial role of 'phatic' imagery – images that tend to be only fleetingly recognised in that small moment of gathering awareness and anticipation before we spring into action. The trick of successful brands is to become so well known that they operate at this not quite-conscious level. They are the new familiars – brief flashes of recognition which insinuate themselves into our perception of the moment. This is the intangible as big business, the micro-second as profit. Think only of Nike's swoosh: how often have you seen it/not seen it?

And, in turn, this emphasis on the phatic brings us to the fourth way: a wholesale restructuring of the spatial and temporal attention of human subjects. Increasingly we are directed to a whole series of objects – we become 'attentive observers'. But, in contrast to many modernist accounts

which stress decay in the capacity for perception, within the context of a larger deterioration of experience, it is just as possible to argue that our perception has, at least in certain senses, been made anew through new means of paying attention. In other words, this is not so much about distraction, and the consequent erosion of the subject, as about the construction of new kinds of subjects that are more easily able to direct concentration hither and thither through the cultivation of a kind of generalised readiness, rather like the continuous vigilance required in the scanning of radar screens. A new 'field of attentive practices' (Crary, 1999, p.7) therefore comes into being which, though it may be part of an expanded field of commodity production, also provides new sensory registers of various kinds: 'spectacular society is not inevitably destined to become a seamless regime of separation or an ominous collective mobilization; instead it will be a patchwork of fluctuating effects in which individuals continually reconstitute themselves – either creatively or reactively' (Crary, 1999, p.370). Modern museums and galleries often seem to reflect this shift in effectiveness. For example, Tate Modern's themed displays often seem to be a means of playing to this restless mentality.

To summarise, in modern life, the insubstantial manifests itself in four related ways; as an interpolation of what cannot be sensed but, to some degree, is known to be there, as the opening up of perception by new instruments of representation, as the 'magical' engagement with the senses by and through the media, and as the forging of new subjects able to tune in to the disturbances in the ether produced by these new geographies.

What is interesting is the degree to which the boundary between substantial and insubstantial is thereby constantly in flux. It is in flux because new geographies of the insubstantial are constantly being created, as is nowadays happening through the life sciences and information technology. It is in flux because there is a constant slippage from substantial to insubstantial and vice versa. And it is in flux because our skills of apprehension of the insubstantial are constantly on the move. For example, nowadays, we are almost certainly primed to notice quick, small movements to a greater degree than in the past.

Transubstantiation

Modern expert systems have become increasingly insubstantial, but in different ways. And, as a result, they are trusted in different ways. In order to show just how differently, I want to take up two examples. Let me start with money. Money has been becoming progressively less substantial. Starting as coin money (specie), in which the material embodied the value it contains, the first major shift towards insubstantiality was the move

Justine's profane sister, Juliette, has 'ruined' a number of rich men by the time she meets and succours her wretched sister, even in the relatively decorous pages of the *Justine* of 1791. At this period, 'ruin', applied to a man, means financial ruin, whereas, applied to a woman, it means only that a woman has engaged in sexual activity, suggesting an actual parallel between a bank balance and a body. A ruined woman is one who has lost her capital assets, a virgin who has been deflowered and hence has nothing tangible to put on the market. Not a woman's face but her unruptured hymen is her fortune; however, if she regards her sexual activity as her capital, she may, once ruined, utilise her vagina to ruin others, as though, in fact, the opening of it allowed her access to a capital sum which had been frozen by virginity. No longer a virgin, she may put her capital to work for her. Angela Carter, *The Sadeian Woman*, 1979

towards paper money. This caused immense angst at the time. How exactly could paper money be trusted?

> By means of paper money, it now seemed, the devil might reverse Lucretius' dictum *ex nihilo nihil fit* (from nothing, nothing is made): he could make something out of nothing. The 'devil in specie' as the money devil was sometimes called, was now personified as a fictive nothing pretending to be something.
>
> Daniel Defoe, considering John Law's paper money in the 1720s ... calls the French land-based paper money experiment a 'chimera' – that is, 'an unreal creation of the imagination, a mere wild fancy; an unfounded conception'. Voltaire writes similarly of 'the chimerical value of paper money bills' and 'the commerce of the imagination' and he describes how, when the bottom falls out of the market, 'real paucity begins to replace fictive wealth' (Shell, 1995, p.69).

Such attitudes persisted for a surprisingly long time. Nothing illustrates this statement better than the arguments in Britain for the move back to that icon of Victorian England, the *gold standard*, as late as 1925. The gold standard had tied the value of the national currency in circulation to the value of gold in storage, so that the Bank of England could always convert its notes 'back' into gold bullion at any time at a known rate. This standard was the central tenet of a system of 'sound money', money whose value was

always known and stable. The return to the gold standard – which proved disastrous and had to be undone in 1931 – had many causes; a wish to return to the prosperous days before the First World War, a desire to avoid the politicization of monetary policy, and the desire for a uniform standard of value amongst them. But just as important was clearly a desire to be able to know the value of money, to back the fictive with the real (Gregory, 1997). Thus J. Beaumont Pease of Lloyds Bank argued for the return to gold on the grounds 'that the whole world, through granting of infidelity in varying degrees and in divers places and in spite of some coquettings in other directions, is returning to its old love. There is no effective rival of any standing or consequence. Gold is almost universally recognised as the only practical measure of international values' (cited in Kynaston, 1999, p.114). And the Chancellor, Reginald McKenna, soon weighed in:

> A nation will think better of itself, will almost regard itself as more honest, if its money is convertible to gold. The fear of being forced off the gold standard acts as a salutary check on the extravagance of Governments ... It is a real advantage to the nation to have a currency founded upon a value which is unswervingly recognised: it inspires confidence and facilitates international transactions... so long as nine people out of ten in every country think the gold standard the best, it is the best (cited in Kynaston, 1999, p.114).

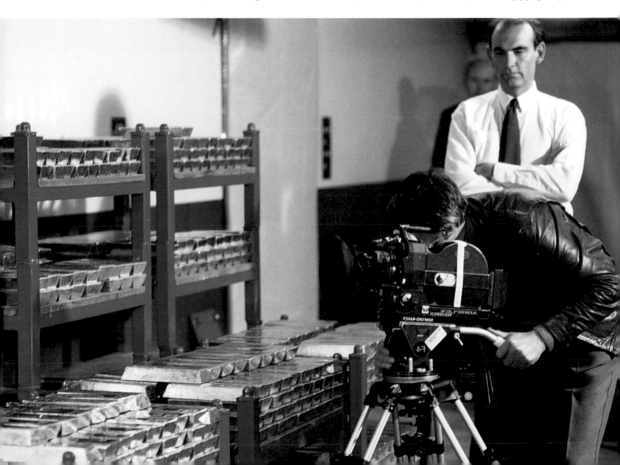

But, over the course of the twentieth century and into the twenty-first, money has continued to 'dematerialise'. Increasingly, it has taken on forms which require no direct physical transfer – like the ubiquitous credit card. This de-materialisation has happened at the level of the international wholesale financial system, much of which now effectively operates as a series of accounts in computer memories. It has also happened at the level of the national retail financial system, where all the traditional visible signs of doing money – cheque-books, bank branches, bank managers and the like – are dying out even though money is no longer backed by tangible guarantors like gold. This has led to a byzantine maze of financial instruments guaranteed by rules and regulations, laws and, of course, independent central banks like the US Federal Reserve and the Bank of England, which have to be both a part of the system and yet also distance themselves from it. However, unlike previous times, there is remarkably little anxiety now about the apparent loss of these traditional representations of money. Generally speaking, the system of money is trusted. Why might this be? To understand, we will consider the case of national retail financial systems. What we can see here are four developments.

First, and most obviously, new representations of money have sprung up. As banks and other financial institutions have got rid of their tangible infrastructures – the bank branches – which used to (literally) speak money so they have increasingly had to turn to other means of signalling their presence, means which can both signal trust in their financial probity and also convey a measure of excitement. Hence the importance of *brands*, all the way from Lloyds' black horse to Virgin's distinctive red, and the new banks like Egg, Goldfish, Marbles and so on. These brands are rolled out as complete systems of signs, making their way on to credit cards, and on to websites. Indeed, signalling a presence on the Internet – which might well become the chief means of doing money – makes the brand even more important, since visual communication will become all. Yet the example of the internet also shows some of the problems. How, for example, to make the transition from the older tangible ways of doing money to the new intangible ways? This is why Intuit's Quicken package, one of the chief pieces of home accounting software, uses an interface borrowed from paper: 'the user interface for Quicken mimicked the familiar look of paper checks and registers, so new users could understand what was being displayed and would have good initial ideas about how to do standard operations, such as filling out checks and entering deposit information' (De Young and Winograd, 1996, p.270). Second, there is the vast penumbra of commentary about money. Since the 1960s a large media industry has grown up whose ⇉

purpose is to write, talk and represent the goings-on of money, from high commentary on the international financial system to the most mundane of television money advice shows. Money is continuously being talked into being (Leyshon, Thrift and Pratt, 1998). Third, and relatedly, doing money has become an ever more pervasive fact of everyday life, haunting our every gesture. Whether one sees this as an index of the triumph of neoliberalism or simply a sign of the sheer diversity of cultural practices in which money is now entangled (Furnham and Argyle, 1998) – and of the many 'moneys' that therefore exist in everyday life (Zelizer, 1994; Doyle, 1999) – the fact is that money is now so caught up in our practices that it often does not need to be represented at all: it is simply a part of the background of contemporary life.

In turn, this means that the symbolic anchors of previous eras – like the buildings of the Bank of England (see Black, 1998, 1999a, b) – simply become signs of the circulation of money, convenient locations from which to report on monetary happenings but no longer accorded much in the way of gravitas. In a sense, the sheer practical ubiquity of monetary exchange produces its own anchor. After all, how many of us can describe what is engraved on a five or ten pound note? Yet we use these notes all the time.

How very different, one might think, from my second example, the world of art. National art institutions such as the Tate still seem to function rather like the temples of finance from earlier times but as custodians of cultural treasures rather than vaults full of gold bullion. And they are part of an enormous and still highly visible global geography of art institutions and intermediaries – not just the museums, galleries, and travelling exhibits which soak up the flows of tourists like enormous pieces of cultural blotting paper (Zukin, 1995) but also the web of auction houses, dealers, commissioning agents and the like which provide impetus of their own. In such institutions art is still displayed, hung, installed. Surely this is not a world which is dematerialising?

Yet it sometimes seems as if this is the case. Increasingly art objects are elsewhere, dislocated, unhinged, phantasmatic. This is not to say that we read art 'as if it were not there' (Fried, 1998). Rather, it is to say that as art has turned to conjecture and concept, so location has itself become a question. Where is the art object? At a minimum, the art object is placed within 'a relay of several interrelated but different spaces and economies including the studio, the gallery,

the museum, art criticism, art history, the art market, etc, that together constitute a system
of practices that is not separate from but open to social, economic and political pressures'
(Kwon, 2000, p.40). And, of course, the artist may go further still,
attempting to construct 'immaterial, process-orientated, ephemeral,
performative events' (Kwon, 2000, p.47) which explicitly try to reach across
spaces, the detritus of those nomadic performances (props, photographs,
illustrations) sometimes becoming objects of value in their own right.

In such circumstances, it is no surprise that, the space of the gallery or
the museum has become an increasingly important art object in itself, taking on the qualities
of authority previously bequeathed to the art object. Indeed, very often the extension of the art
object has been accompanied by increasing attention being paid to
delineating and examining its immediate context in the museum or gallery,
taking note of the parameters of such spaces and reconfiguring them:
institutional space and the space of the object don't just coincide, they
collude and collide.

So how are we left to trust in and about art, now that the certainties of its
interpretation have been dislocated? In five ways, I think, which together
constitute a kind of practical aesthetics. To begin with, there is the simple
fact that the art object has monetary value; quite simply, if something is
valuable, it evolves a price. In the art economy, monetary value is fixed by ⟫⟶

a complex formation made up of the state of the art market, current aesthetic mores, investor behaviour and so on. Furthermore, this monetary value has been enhanced by art's move into the service industries which has allowed the artist – and the curator – to move both up and down the production chain.

> The artist as an over-specialised aesthetic object maker has been anachronistic for a long time already. What they *provide* now, rather than *produce*, are aesthetic, often 'cultural-artistic' services. If Richard Serra could once distil artistic activities down to their elemental physical actions (to drop, to split, to roll, to fold, to cut...), the situation now demands a different set of verbs: to negotiate, to co-ordinate, to compromise, to research, to organise, to interview) etc. The shift was forecasted in conceptual art's adoption of what Benjamin Buchloh has described as the 'aesthetics of administration'. The salient point here is how quickly the aesthetics of administration, developed in the 1960s and 1970s, has converted to the administration of aesthetics; now he or she is a facilitator, educator, co-ordinator, and bureaucrat. Additionally, as artists have adopted managerial functions of art institutions (curator, educational, archival) as an integral part of their creative process, managers of art within institutions (curators, educators public program directors), who often take their cues from these artists, now function as authorial figures in their own right (Kwon, 2000, p.53).

Then, second, there is the gallery or museum itself. Inclusion in a museum or gallery singles out art as art. For example, the location of many art objects together, consecrated by such elements as the presence of numerous viewers, the giving of bequests, and the judgements of reviewers, validates the art object of the gallery or museum; object becomes environment. In turn, the museum or gallery space itself becomes a gold standard which a relay of other different but related gallery and museum spaces confirm but the value is distributed throughout the cultural economy rather than existing in one location like the Bank of England. And, increasingly, we see a global space war breaking out, as museums and galleries compete to stage more and more spectacular settings. Third, art, like money, is increasingly talked and written into existence by a vast media machine which sets each art object, gesture and project into a never-ending flow of discourse. Art journals, books and catalogues. Reviews, lectures, general criticism. Slides, postcards, replicas. Curators, dealers, consultants. The history of this judgement machine largely remains to be written (Preziosi, 1998). Fourth, the artist can play to these changes. For example, taking a number of lessons from Warhol, some star artists now function rather like brands, producing motifs which prompt instant recognition. And fifth and finally, there is the genesis of various practices of the consumer

That remarkable souvenir, the postcard, is characterized by a complex process of captioning and display which repeats this transformation of public into private. First, as a mass-produced view of a culturally articulated site, the postcard is purchased. Yet this purchase, taking place within an 'authentic' context of the site itself, appears as a kind of private experience as the self recovers the object, inscribing the handwriting of the personal beneath the more uniform caption of the social. Then in a gesture which recapitulates the social's articulation of the self – that is, the gesture of the gift by which the subject is positioned as place of production and reception of obligation – the postcard is surrendered to a significant other. The other's reception of the postcard is the receipt, the ticket stub, that validates the experience of the site, which we now can name as the site of the subject himself or herself.

Susan Stewart, *On Longing*, 1984

which also validate art. Of these, perhaps the most important has been the rise of the collector; collecting is a consumer practice which now reaches across many different social groups and which, by combining art and probable monetary gain, produces another means of consecration. These five means of trusting the art object, and the practices and institutions of art, come together in the gallery or museum shop. It is no accident that the shop is the focal point of so many modern galleries and museums: and not just because the act of purchase provides a purchase on art. More to the point, the shop now provides something like a quarter of the income of many galleries and museums. It is, quite literally, a focal point in the spaces of art, proof positive of art's existence and integral to its distribution (at the same time, it also points to all the other functions of museums and galleries – stores, security offices, curators departments, and so on which, in their own way, also help to keep art in motion).

So the authenticity of art is increasingly distributed around a network of art practices, and art's value lies in the process by which judgement and trust shuttle back and forth around the network. In this aspect at least, money and art have become rather similar kinds of global economies, struggling to constantly re-invent themselves so as to constantly move the game on. The worry, of course – one might even say the 64,000 dollar question – is whether all that is left are echoes, leaving trust to slip gradually away.

Value Added

In this brief essay, I have tried to give a sense of just what interesting times we live in, interesting because of the struggle to *give birth to new forms of value* which draw to a much greater degree on the insubstantial.

To begin with, these are times that are caught in valuing the realm of the insubstantial. By this, I do not just mean that there is a battle underway to place a monetary value on things previously considered to be outside the monetary sphere – though that is indeed the case (think only of the current controversy concerning the correct monetary value to be placed on intangible elements like brands when drawing up a business balance sheet, or the monetary value of a glass filled with the air of Paris). I also mean that the growing realm of the insubstantial that I have traced out provides a forcing ground for new forms of value. In particular, commerce, as a result of the increasing importance of functions like marketing, design and advertising, has tried to deploy means of intensifying experience drawn from art in order to produce new kinds of commodities, commodities which are loaded up with a full range of sensory pleasures (Pine and Gilmore, 1999). For example, attempts by advertisers to connect commodities to emotions often rely

And these are times in which institutions like the Bank of England and Tate can still function as guarantors

on artistic means of release.

Then, these are times in which the value of the insubstantial has become increasingly apparent. Chiefly, this new visibility is the result of the great discourse engines like money and art – traceries of paper, electronic messages and code which create, debate, and police value, and which, through text, image and sound, are busily redefining what counts as existence. The work of redefinition operates at a number of levels. On one level, there is the prominence of theory. As Miller (1998) has argued, more and more of the world is forced to change itself in order to match the abstract theoretical models produced by various kinds of commentators. For example, we are seeing the rise of a state which is run according to therapeutic models of how people are as a justification for its programmes and policies (Nolan, 1998, Cameron, 2000). On another level, there is the burgeoning world of written rules, a web of regulation that is now so complex that it is difficult to take in, and one which, furthermore, is increasingly embedded in technologies like computer software which are themselves nothing but bundles of written rules. On one more level, the conduct of discourse is certainly being reworked as these theories and rules are discussed and negotiated moment by moment.

of value. But no longer as before – as simple storehouses of value. Now they are best thought of as *underwriters*. They both demonstrate that a discourse of value is there, and guarantee its continuance. But, in contrast to the old Bank and art galleries, they do not so much guarantee matter as *potentiality*. Their function is to guarantee that change will continue profitably on.

We need to come to terms, then, with the insubstantial. This will not be easy. And yet it is also crucial. For one thing, the insubstantial has important effects – all the way from currency crises to the invention new forms of imagination. For another, it demands a change in how we think of the world. In the past, such a realm might well have been thought of as a reflection or a refraction of 'material reality'. But, increasingly, it is what the world now *is*; the insubstantial, in other words, is no longer a ghost in the machine. Instead, the ghosts *are* the machine.

A Short History of the Tate Gallery

The invention of the sugar cube, a second marriage and a nationalistic desire to give due prominence to British art led to the founding of the Tate Gallery. British painting had always been included in the National Gallery's collection, but its representation in Trafalgar Square was restricted by growing congestion, even after the building was enlarged in 1876. For a period, thirty-four works by Turner, released from his vast bequest, and seventy British paintings donated by Robert Vernon, had to be housed in a building next to the South Kensington Museum. This set a precedent for exhibiting British painting separately and heightened awareness of a need for a national gallery of British art.

The man in whom this idea took hold was Henry Tate. Born in 1819, the seventh son of a Liverpool Unitarian clergyman, Tate entered the grocery trade at the age of thirteen, acquired his own business at twenty and within a further six years owned a chain of shops and had expanded into wholesale trade. He then moved into sugar refining and took advantage of a patent, which others had turned down, for producing dry granulated sugar. In 1878 he took a further risk and adopted the new Langen cube process for cutting up sugar loaves, which actually proved so successful that cubes soon superseded the tall cones of sugar. Four years earlier Tate had gone to London to investigate the possibilities of expanding his business, with the result that he built the Thames Refinery at Silvertown and settled into a large mansion at Streatham Common. There he made it his annual practice to host a 'painters' dinner' for his artist friends, usually on the eve of the private view of the Royal Academy's Summer Exhibition. Strawberries, which in his own

Sir Henry Tate, Bt (1819–1899) from a contemporary engraving

One of several proposed designs for the Tate Gallery made by Sydney R.J. Smith in the 1890s

6

ensued, Tate volunteered to pay for the building of a new gallery, to a cost of £80,000. Even after this magnificent offer, the government procrastinated, and in 1892 Tate withdrew it. Then came a change of government, and Sir William Harcourt, the new Chancellor of the Exchequer, reopened negotiations. In the course of a conversation lasting just half an hour, he and Tate resolved matters conclusively: a new palace of art was to grow on the site of the old Millbank Penitentiary.

One advantage of the chosen site was that there was space for considerable expansion. When the Gallery opened in 1897, plans for the second stage in the building programme hung in the central hall. Though Tate again defrayed the cost he stated publicly that he had no wish to attach his name to the title of the Gallery. Initially called the National Gallery of British Art, it in fact fell short of Tate's ideal, for it was at first merely an annex of the National Gallery. Although granted its own Board of Trustees in 1917 it did not achieve autonomous legal status until 1954. In 1920 the official title was changed to the National Gallery, Millbank, to reflect the changes in the scope of the Collection. However, Tate's name was so firmly attached to the institution that in 1932 the Board 'unanimously agreed that the Gallery should henceforth be officially known as "The Tate Gallery"'.

Relations between the Tate and the National Gallery with regard to their respective collections proved contentious, but even greater difficulties arose over the administration of the Chantrey Bequest. In his will of 31 December 1840, the sculptor Sir Francis Chantrey had set up a trust, the income from which was to encourage British painting and sculpture.

An engraving of Millbank Penitentiary in 1829, later the site of the Tate Gallery

Purchases were to be exhibited for a month at least at the Royal Academy and were then to form part of a public national collection of British art. Chantrey had made no provision for a permanent home for this collection, as he was confident that the Government would in time provide it. Once the Tate came into existence it became the recipient of Chantrey purchases. By 1904 it housed 109 Chantrey works, yet because the administration of this bequest lay solely with the President and Council of the Royal Academy, the Tate Gallery had no power of selection or elimination over what was bought. In time the Gallery acquired the right to have representatives on the Recommendation Committee, but even after the Tate had

8

well-tended greenhouses invariably ripened before Easter, were a special feature of these dinners.

This self-made man had a pronounced philanthropical bent, and the total aggregate of his gifts to charities, churches, hospitals, educational institutions, libraries and art galleries amounted to a million pounds. Liverpool benefited significantly from his donations, and after his move south he paid for the building of free libraries at Lambeth and Brixton, also giving £5,000 towards the cost of another at Streatham. But, though Tate had been a Liberal councillor in Liverpool for a short time, he preferred to take little part in public life. He abhorred speech-making, and had excused himself from the public opening of Liverpool's Hahnemann Hospital which he had endowed with £20,000. All this changed in 1885 when, two years after the death of his first wife, he married the thirty-four year old Miss Amy Hislop, who relished the prospect of being seen in public on platforms alongside the Prince of Wales. At the age of sixty-six Tate – said to be undemonstrative, withdrawn and shy – had a late flowering and as benefactor pursued a more public role.

The history of the Tate Gallery begins with the letter Henry Tate wrote to the National Gallery on 23 October 1889. In this he offered to donate a collection of modern British art, on the condition that rooms be provided or built exclusively for its reception. His offer, initially declined because of the shortage of space at Trafalgar Square, was remade to the Chancellor of the Exchequer, George Goschen, but with the additional demand that the Lords of the Treasury sanction the establishment of a separate institution. In the debate that

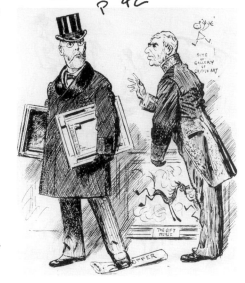

Cartoon from *Fun*, 16 March 1892. The accompanying caption read:

TATE À TATE.
[Mr. Tate has withdrawn his munificent offer. *Daily Paper*]
Goschen.–"Much Obliged, but we are a Nation of Shopkeepers and We don't want any Art Today, Thank You"

7

is this because of the reliance on gift and donation?

obtained a degree of influence over purchasing, the Chantrey Bequest continued to point up the differences between the growing independence of the Tate and the increasingly conservative Royal Academy.

As an art institution, the Tate has always aroused more than usual affection. Equally, its commitment to contemporary art has stimulated a huge amount of controversy. In its early years, however, it led a relatively quiet existence, one critic dismissing it as a dumping ground for sentimental Victorian painting. But it was steadily changing its character. Its first Keeper, Charles Holroyd, an efficient administrator, talented painter and scholar, oversaw the second extension, when eight galleries were added to the existing seven. Before moving to the Directorship of the National Gallery in 1906, he hung the first room of Turners at the Tate, fourteen pictures previously confined to offices at Trafalgar Square and only visible to the public on application. Turner's importance was reinforced during D.S. MacColl's Keepership with the building of the Turner galleries, paid for by Sir Joseph Duveen. When ill health obliged MacColl to depart in 1911 for the less arduous job of Keeper of the Wallace Collection, Charles Aitken took over.

At first this former Director of the Whitechapel Art Gallery seemed a rather unimpressive, austere, somewhat effeminate man, with limited powers of expression, an unlikely candidate for a position of leadership. But, according to John Rothenstein, the opportunities and responsibilities imposed by the Tate transformed him. With clarity and firmness of purpose he introduced a policy of loan exhibitions and in various ways extended the scope of the Tate. Meanwhile, Lord Curzon's

1915 report of the findings of a Committee of National Gallery Trustees led to alterations in the Gallery's constitution. In 1917 the Tate was made responsible for the national collection of British painting of all periods, and also for the national collection of modern foreign painting. Its administration was placed in the hands of a separate Board of Trustees and its Keeper advanced to the rank of Director.

If art became endangered with the outbreak of war in 1914, the first blow came from Suffragettes. On 10 March a Miss Richardson, subsequently nicknamed Slasher Mary, attacked the National Gallery's 'Rokeby Venus', cutting through the

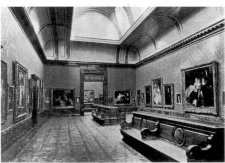

The Sargent Gallery in 1926

canvas in seven places. The Tate, like the National Gallery, closed for a fortnight to consider precautionary measures. It closed again in September, this time for five years. The paintings were dispersed into various parts of the Underground, making way in the Gallery for detachments from certain Ministries. For part of the war the Tate also gave space to wounded soldiers from the Queen Alexandra Military Hospital.

During the 1920s and 1930s the Tate's acquisitions were curtailed by the absence of any purchase grant from the government. The only official financial assistance received came via the National Gallery from the annual product of the Clarke Fund which, representing £575 in 1918, was for the purchase of British pictures. To this was added money from other small bequests, and from 1926 onwards profits from the sale of publications and prints were also made available to the Board for the purchase of works of art. Inevitably the Gallery depended greatly on the generosity of donors – on the National Art Collections Fund and the Contemporary Art Society, as well as private individuals such as Samuel Courtauld, who made a significant impact on the modern foreign collection by setting up a fund specifically for the acquisition of French art.

As early as 1916, Sir Joseph Duveen's son, the formidable art dealer who helped shape the private collections formed by the Americans Henry Frick and Andrew Mellon, had urged the Tate to collect contemporary foreign art. Like his father, Duveen was hugely generous to the Tate, paying for the Rex Whistler decorations in the Refreshment Room (now the Restaurant), and for the building of the Sargent and Modern Foreign Galleries, which were designed by John Russell Pope in

collaboration with Messrs Romaine-Walker and Jenkins. This last development introduced the domed octagon, intended to emphasise the centre of the building, and, at Duveen's behest, an existing gallery was removed in order to open up a central vista that continues the axial route provided by the entrance. Though Duveen made significant gifts to other art institutions, he chose when raised to the baronetcy to honour the Tate in his choice of title, and became Lord Duveen of Millbank, apparently unaware of the irony that while making magnificent gifts to the nation he had simultaneously denuded it by selling England's art treasures abroad.

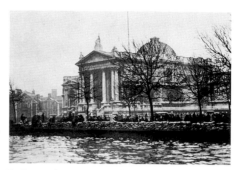

The Thames in flood in 1928, with workmen building a wall of sandbags

10

Rothenstein had appointed on to his staff, the Board began an investigation into certain aspects of the Gallery's administration. Rothenstein survived an attempt to force his resignation, but so vicious and malignant was this affair, that the *Spectator* spoke of 'vultures swooping in the frosty air around Millbank.'

In 1972 the Gallery purchased Carl Andre's 'Equivalent VIII', better known as 'The Bricks', and this aroused another voluminous controversy when exhibited in 1976. By then under the directorship of Norman Reid (later Sir Norman), the Tate had seen a new wave of professional staff enter at every level of the establishment. A Conservation Department, which had links with the Courtauld Institute, had been set up. Another major department was that dealing with Exhibitions and Education, and the steady increase in numbers of visitors also made it necessary to create an Information Department. In 1977 the success of the Stubbs Appeal, launched to raise money towards the purchase of two works by George Stubbs that had recently come on the market, marked the start of growing emphasis on fundraising and sponsorship. In 1979 a new extension filled in the final quarter of the original site.

Although there was a dramatic increase in professionalism, an off-the-cuff remark could still engender the unexpected. When Reid told the *Evening Standard* that instead of another Picasso exhibition he would rather celebrate this artist's ninetieth birthday by releasing ninety pigeons from the Tate steps, he received a telegram the next day from a willing bird fancier. As a result Reid, surrounded by local schoolchildren, all clutching pigeons, released the first of the birds as television cameras recorded this salute to Picasso.

Sir Norman Reid and schoolchildren releasing the first of ninety pigeons in honour of Picasso's ninetieth birthday, 25 October 1971

12

Tate as guarantee

Towards the end of his association with the Tate Gallery Duveen, by then a sick man, fell out with its director. This was J.B. Manson, who had succeeded to the directorship in 1930, having entered the Tate in 1912 as a clerk, as a result of his wife leaning on her friendship with Aitken. Previously a painter associated with the Camden Town School, Manson always hankered after his former occupation, found himself increasingly out of sympathy with modern art and was so drunk at one board meeting that he fell off his chair and had to be carried out wrapped in a blanket. In April 1938, when Marcel Duchamp selected and shipped a sculpture exhibition to London, where it was to be shown at Peggy Guggenheim's gallery, Manson was asked by the customs to verify that the goods were works of art and therefore did not infringe the law to protect stonecutters from the importation of cheap Italian tombstones. Confronted with an egg-like marble by Brancusi, Manson declared it 'quite idiotic' and 'not art', causing an outbreak of protest and controversy. Not long after, his drunken behaviour at an official dinner in Paris brought about his dismissal.

Works of art returning from wartime storage in the London Underground. The work in the centre is 'Wake' by Edward Burra. Photo: © London Transport Museum

Under Manson, the administration at the Tate had fallen into disarray. The Chairman of the Board, Sir Evan Charteris, effectively took upon himself the role of Director until the appointment of John Rothenstein in 1938. Various reforms were under way when the Second World War began and once again the collections were evacuated. The Tate had first experienced disaster in 1928, when the Embankment Wall gave way and up to nine feet of Thames water flooded certain of the basement galleries. It now underwent far more severe damage, suffering repeatedly from blast or incendiary bombs. After the bombs came the rain, falling through galleries open to the skies, through heating grilles or burnt floors into the basement.

Though Rothenstein enjoyed several halcyon years at the Tate after the return to peace, he was later at the centre of the so-called Tate Affair, which for two years during the early 1950s earned the Gallery much adverse publicity. Stirred up by the machinations of Leroux Smith Leroux, a South African whom

the Tate as a raft of related sites

Tate Modern opened at Bankside – 2000

Regional development became the theme of subsequent years. Under the directorship of Alan Bowness the idea of the Tate in the North, as it was initially called, became a reality when Tate Gallery Liverpool opened in 1988. The decision to build a gallery in St Ives also received approval, Tate Gallery St Ives finally opening in 1993 on the site of a disused gasworks.

Meanwhile, at Millbank, the opening of the Clore Gallery in 1987, designed by James Stirling, had finally brought to fruition a project that had been mooted for decades – the holding and exhibiting under one roof of the entire collection of paintings and drawings bequeathed by Turner to the nation. At the time of the Clore's opening there were further plans for two new museums, one devoted to modern sculpture, the other to new art, as well as for a study centre. All these were to be housed at the back of the Tate, on the site adjacent to the Queen Alexandra Military Hospital – which now also belonged to the Tate, having been obtained with the help of the first Minister of Arts, Jenny Lee.

Though the new museums scheme was abandoned, expansion continues to be at the centre of the Tate's policy. The Tate has not nearly enough room to show all its treasures at once. The current Director, Nicholas Serota, implemented a policy of changing the displays every year, so that works which would otherwise remain in storage can be seen: the first of these *New Displays* opened in 1990. However, it has become clear that the Tate Collection has outgrown the site at Millbank. With the approach of the Gallery's centenary, plans are on course to transform Sir Giles Gilbert Scott's Bankside Power Station into the Tate Gallery of Modern Art. The present Tate will revert to its original function and be developed as the Tate Gallery of British Art. This ambitious project concludes a story of continuous development and a growing commitment to contemporary art, however new or difficult. Over the past one hundred years the Tate Gallery has grown into one of the greatest and most stimulating art institutions in the world.

Written by Frances Spalding

Frances Spalding is writing a full history of the Tate Gallery, which will be published in 1997

Directors past and present: Nicholas Serota, Sir Norman Reid, Sir John Rothenstein and Sir Alan Bowness in 1988, standing in front of Sir Hubert von Herkomer's 1897 portrait of Sir Henry Tate

Photographic credits

All pictures were taken at Tate Britain, Tate Modern and the Bank of England except pp.30, 32-33, 35, 36, 50, 52-53, 98, 99, 103. All by Neil Cummings and Marysia Lewandowska in 2000/2001, courtesy chanceprojects

Courtesy Bank of England Museum: pp.2, 38, 41, 54, 56, 69-70, 77, 82, 87, 88, 91, 93.

p.2: James Gillray, *Midas Transmuting All into Gold Paper*, 1797
p.6: Tate from Southwark station. Photo Sam Ely
p.8: Pimlico underground station
p.10-11: Tate security and Bank of England staff
p.12: Original subscription to capital of 1694, stored at the Bank of England Museum
p.15: One week's worth of spent blades, Tate's Paper Conservation studio, Millbank
pp.16-29: John Keyworth, 'From a National to a Central Bank', Bank of England Souvenir Guide, 1998.
p.30: 'It's the thought that counts.' Limited-edition print, issued by the artists as a free gift to visitors to Tate Modern and the Bank of England Museum
p.35: Pepper sachet, SAS Airlines
p.36: Old money bag, produced by prison inmates
p.38: Exchange
p.41: £25,000 at the Bank of England printing works
p.43: Henri Matisse's *The Snail* leaving Tate Britain for Tate Modern, February 2000
p.45: Henry Tate presenting a model of the future gallery. From the press cutting album, Tate Archive
p.47: Macauley Studio B Education Suite, Tate Modern
p.49: Boardroom, Tate Britain
p.50: Donor's gift from the National Blood Service

p.51: 60p debt, from the offices of the Bank of England Museum
p.52-3: Tate & Lyle sugar cubes
p.54-5: Incineration of used banknotes, Bank of England printing works
p.56: The banknote presses, Bank of England printing works
p.58, top: Marcel Duchamp's *Fountain* in Tate's Sculpture Conservation studio, Millbank
p.58, bottom: Paintings at Tate's store, Southwark
p.60: One of Tate's painting stores, Southwark
p.61: First day at Tate Modern's shop, Level 1
p.62-3: Goody bags at a children's event, Tate Modern
p.64-5: Packing Bridget Riley's paintings, art-handling, Tate Modern
p.67: Tate Archive store at Millbank
pp.69-70: Counting money at the Bank of England printing works
p.75: Bloomberg Reading Point, Level 5 west, Tate Modern
p.77: Incineration of used banknotes at the Bank of England printing works
pp.78-79: Starr Auditorium at Tate Modern
p.80: Reflected view of the City, from Level 7 at Tate Modern
p.82: New storage system in the Records Office of the Bank of England, 1977
p.84: Catalogues from Tate Library stack, Millbank
p.86-87: Notes ready for destruction, 1962
p.91: First IBM computers installed at the Bank of England, 1973
p.92: Tate's sculpture store, Southwark
p.93: Filming the bullion store at the Bank of England
p.95, top: Tate Archive, Millbank
p.95, bottom: Level 1 shop, Tate Modern
pp.96-7: Monetary Analysis office, Bank of England
p.101: Level 1 shop, Tate Modern
p.103: www.ftmarketwatch.com and www.bloomberg.com

p.104: Visitors to Tate Modern
pp.106-110: Frances Spalding, 'A Short History of the Tate Gallery', *Tate Gallery Centenary Diary*, 1997.

Sources of quotations

p.11: John Locke, in Peter Larslet (ed.) *Two Treatises of Government*, Cambridge University Press, 1988
p.34: Aristotle, *The Nicomachean Ethics*, Penguin 1976
p.46: Karl Marx, *Capital Vol.1*, Penguin, 1976
p.75: Charles Dickens, *Dombey and Son*, Oxford University Press, 1989
p.78: Sigmund Freud, from *The History of an Infantile Neurosis*, The Hogarth Press and Institute of Psychoanalysis, 1961
p.80: 'Fidelity Fiduciary Bank' from Walt Disney's *Mary Poppins*. Words and Music: Richard M. Sherman/Robert B. Sherman. Copyright 1963 Wonderland Music Company, Inc. All Rights Reserved. Used by Permission
p.91: Angela Carter, *The Sadeian Woman*, Virago Press, 1983
p.101: Susan Stewart, *On Longing*, Duke University Press 1994

Notes on contributors

Frances Morris is a Senior Curator at Tate Modern.

Marilyn Strathern is William Wyse Professor in the Department of Social Anthropology at the University of Cambridge. Her research interests are divided between Melanesian and British ethnography. *The Gender of the Gift* (1988) is a critique of anthropological theories of society and gender relations as they have been applied to Melanesia, while *After Nature* (1992) comments on the cultural revolution at home.

Nigel Thrift is a Professor in the School of Geographical Sciences at the University of Bristol. His recent publications include *Spatial Formations* (1996), *Money/Space* (1997), *Shopping, Place and Identity* (1998), *City A–Z, Thinking Space* and *Cities for All the People Not the Few* (all 2000).

Jeremy Valentine is Lecturer in Media and Cultural Studies at Queen Margaret University College, Edinburgh. He has published in the area of political thought and cultural studies and is currently editing a special issue of *Cultural Values* on 'Culture and Governance'.

Bibliography

Amato, J.A (2000) *Dust. A History of the Small and Invisible*, Berkeley: University of California Press

Aristotle (1976) *The Nicomachean Ethics*, London: Penguin

Bataille, G (1988) *The Accursed Share*, New York: Zone Books

Baudrillard, J (1994) *The Transparency of Evil*, London: Verso

Benveniste, É (1971), *Problems in General Linguistics*, Coral Gables: University of Miami Press

Black, I.S (1999a) 'Rebuilding 'The Heart of Empire': bank headquarters in the City of London, 1919–1939' *Art History*, pp.22, 593–618

Black, I.S (1999b) 'Imperial Visions: re-building the Bank of England, 1919–1939' in Driver, F. Gilbert, D. (eds.) *Imperial Cities. Landscape, Display and Identity* Manchester: Manchester University Press, pp.96–113

Black, I.S (2000) 'Spaces of Capital: bank office building in the City of London, 1839–1870', *Journal of Historical Geography*

Bourdieu, P (1990), *The Logic of Practice*, Cambridge: Polity Press

Brown, P (1992) *Power and Persuasion in Late Antiquity*, Madison: The University of Wisconsin Press

Cameron, D (2000) *Good to Talk? Living and Working in a Communication Culture.*, London: Sage

Clark, T.J (1999) *Farewell to an Idea. Episodes from a History of Modernism*, New Haven: Yale University Press

Crary, J (1999) *Supensions of Perception. Attention, Spectacle and Modern Culture*, Cambridge, Mass: MIT Press

Derrida, J (1992) *Given Time: 1. Counterfeit Money*, Chicago: The University of Chicago Press

Doyle, K.O (1999) *The Social Meanings of Money and Property. In Search of a Talisman*, Thousand Oaks: Sage

Ede, S (ed.) (2000) *Strange and Charmed. Science and the Contemporary Visual Arts*, London: Caloustic Gulbenkian Foundation

Fried, M (1998) *Art and Objecthood*, Chicago: University of Chicago Press

Furnham, A. Argyle, M (1998) *The Psychology of Money*, London: Routledge

Gell, A (1998) *Art and Agency. An Anthropological Theory*, Oxford: Clarendon Press

Giddens, A (1991) *Modernity and Self-identity. Self and Society in the Late Modern Age*, Cambridge: Polity Press

Gregory, C (1997) *Savage Money* London: Harwood Publishers

Heidegger, M (1972), *On Time and Being*, New York: Harper and Row

Hetherington, K, Law, J (ed.) (2000) Special Issue. ' After Networks' *Environment and Planning D. Society in Space*

Katz, J (1999) *How Emotions Work* Chicago: University of Chicago Press

Kwon, M (2000) 'One Place after Another: Notes on Site Specificity' in Suderburg, E (ed.) *Space, Site, Intervention, Situating Installation Art* Minneapolis: University of

Minnesota Press, pp.38–63

Leyshon, A, Thrift, N.J (1997) *Money/Space. Geographies of Monetary Transformations* London: Routledge

Leyshon, A, Thrift, N.J, Pratt, J (1998) 'Reading financial services: consumers, texts and financial literacy', *Environment and Planning D. Society and Space*, pp.16, 29–35

Löfgren, O (1997) 'Scenes from a troubled marriage: Swedish ethnology and material culture studies' *Journal of Material Culture*, pp.2, 95–114

Löfgren, O (2000) 'Moving metaphors', in Berg, P, Linde-Laursen, Λ, Löfgren, O (eds.) *Invoking a Transnational Metropolis*, Lund: Studentlitteratur, pp.27–54

Lury, C (1999) 'Marking time with Nike: the illusion of the durable' *Public Culture*, pp.11, 1–14

Mauss, M (1990), *The Gift: The Form and Reason for Exchange in Archaic Societies*, London: Routledge

Miller, D (1998) 'A theory of virtualism', in Carrier, J, Miller, D (eds.) *Virtualism*, Oxford: Berg

Moore, R.O (2000) *Savage Theory. Film as Modern Magic*, Durham, N.C: Duke University Press

Nolan, J (1998) *The Therapeutic State*, Albany, New York University Press

Pine, J, Gillmore, J (1999) *The Experience Economy*, Boston: Harvard Business School Press

Preziosi, D (ed.) (1998) *The Art of Art History*, Oxford, Oxford University Press

Further reading

Schrift, A.D (1997), *The Logic of the Gift*, London: Routledge

Shell, M (1995) *Art and Money*, Chicago: University of Chicago Press

Thomas, N (1999) *Possessions. Indigenous Art/Colonial Culture*, London: Thames and Hudson

Thrift, N.J (1996) *Spatial Formations*, London: Sage

Titmuss, R.M, (1997), *The Gift Relationship; from human blood to social policy*, London: London School of Economics Books

Veyne, P (1990), *Bread and Circuses*, London: Allen Lane

Weiss, B (1996) *The Making and Unmaking of the Haya Lived World*, Durham: N.C, Duke University Press

Welchman, J.C (2000) 'Public art and the spectacle of money: an assisted commentary on Art Rebate/Arte Reenolso in Suderburg, E (ed.) *Space, Site, Invention. Situating Installation Art*, Minneapolis: University of Minnesota Press, pp.236–251

Winograd, T, de Young, L (1996) 'Organisational support for software design' in Winograd, T, *Bringing Design to Software* Reading, Mass: Addison Wesley

Zelizer, V (1994) *The Social Meaning of Money*, New York: Basic Books

Zukin, S (1995) *The Cultures of Cities*, Oxford Blackwell

General

Arjun Appadurai (ed.*)*, *The Social Life of Things*, Cambridge 1988

Georges Bataille, *The Accursed Share: Vol.I*, New York 1993

Jean Baudrillard, *Symbolic Exchange and Death*, London 1993

Tony Bennett, *The Birth of the Museum*, London 1995

Pierre Bourdieu, *The Field of Cultural Production*, London 1993

Philip Coggan, *The Money Machine*, London 1995

Ian Cole & Nick Stanley (eds.), *Beyond the Museum: Art, Institutions, People*, Oxford 2000

Lynne Cooke and Peter Wollen (eds.), *Visual Display: Culture Beyond Appearances*, Seattle 1995

Douglas Crimp, *On the Museum's Ruins*, Cambridge Mass. 1993

Carol Duncan, *Civilizing Rituals: Inside the public art museum*, London 1995

Thomas Frank, *One Market Under God*, London 2000

Jean Joseph Goux, *Symbolic Economies: After Marx and Freud*, Cornell 1990

Reesa Greenberg, Bruce W. Ferguson & Sandy Nairne (eds.), *Thinking About Exhibitions*, London 1996

Andrew Leyshon & Nigel Thrift (eds.), *Money Space*, London 1997

Karl Marx, *Grundrisse*, London 1993

Geoff Mulgan (ed.), *Life After Politics*, London 1997

Craig Owens, *Beyond Recognition: Representation, Power and Culture*, California 1994

Marc Shell, *Money, Language, and Thought*, California 1982

Georg Simmel, *The Philosophy of Money*, London 1978

Frances Spalding, *The Tate: A History*, London 1998

Susan Stewart, *On Longing*, Duke 1993

Marilyn Strathern, *Property Substance & Effect*, London 1999

Mark Wallinger & Mary Warnock (eds.), *Art For All*, London 2000

Publications by Neil Cummings and Marysia Lewandowska

Lost Property, Chance Books/PADT, London 1993

Reading Things, Sight Works/Volume Three, Chance Books, London 1993

Pour Les Curieux, Ecole superieure d'art visuel, Geneva/The London Institute 1998

The Value of Things, August/Birkhäuser, London/Basel 2000

Documents, Photoworks, Brighton 2001